LONDON'S EAST END

THROUGH TIME

Michael Foley

AMBERLEY PUBLISHING

To a very special little princess, Lois

First published 2011

Amberley Publishing
The Hill, Stroud
Gloucestershire, GL5 4EP

www.amberley-books.com

Copyright © Michael Foley, 2011

The right of Michael Foley to be identified as the
Author of this work has been asserted in accordance
with the Copyrights, Designs and Patents Act 1988.

ISBN 978 1 4456 0513 5

British Library Cataloguing in Publication Data.
A catalogue record for this book is available from
the British Library.

Typeset in 9.5pt on 12pt Celeste.
Typesetting by Amberley Publishing.
Printed in the UK.

Introduction

The East End of London has always been seen as the poor relation of the city. From medieval times the area to the east outside the city walls was the home of the less desirable elements of the capital's population. During the Napoleonic wars it was even said that the population of the poorer areas of London were to be more feared than a French invasion.

However, there have always been more affluent pockets in the east. When the area consisted of small rural villages, a number of fine houses stood in the areas around the small settlements. A majority of these disappeared during the spread of London in the nineteenth century, which also engulfed the villages.

It was during the nineteenth century that the East End formed its long-lasting image of an area dominated by industry and the docks that lined the Thames. It was in relation to these industries – such as shipbuilding and matchstick production – that industrial illness and disasters caused hundreds of deaths among the working poor. During the Second World War, it was the East End that took the brunt of enemy bombing of the capital.

As will be seen from this series of old images from around a century ago, much has changed. Some of the buildings may look remarkably similar but the people who now live in the East End are more likely to have their roots in other parts of the world than in other parts of London. The docks are gone, replaced with much grander buildings, and the river is now full of pleasure craft rather than ships carrying goods into the city.

The East End of London is a fascinating area of numerous cultures and races with shops and markets selling goods unimaginable a few years ago. Along with this there are a few surprises that one wouldn't expect to find in such a built-up area such as the open spaces of Wanstead Flats, West Ham Park and Victoria Park.

The expansion of London has continued, with outer London Boroughs such as Redbridge, Barking and Havering in more recent times becoming part of East London. Whatever your interest hopefully you will find something to satisfy it in the varied images of what was and is now East London.

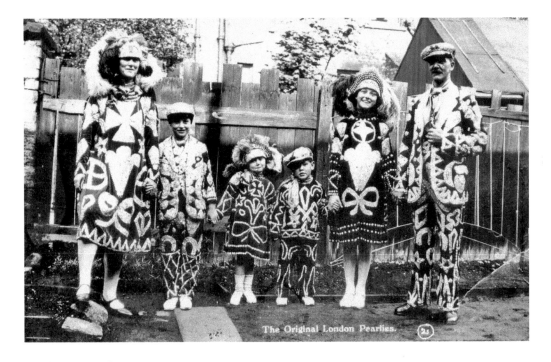

The Original London Pearlies.

Pearly Kings and Queens
The Pearly Kings and Queens of London have their origins in the form of a late-nineteenth-century road sweeper Henry Croft. Copying the fashion of costermongers who decorated their clothes with pearl buttons, Henry used buttons he found while sweeping the roads to cover his whole suit. He was then in demand for charity work. The tradition has continued, with many pearly kings running in the family and they still raise money for charity.

Aldgate Pump EC3

Aldgate pump is an ancient well from the City of London. It was moved to its present site at the junctions of Aldgate High Street, Fenchurch Street and Leadenhall Street in 1876. It was used as a drinking fountain until it was found to be contaminated by the bodies buried in local cemeteries. It marks the beginning of the A13 road, which runs through East London to the Essex coast. The pump now stands amongst numerous office blocks

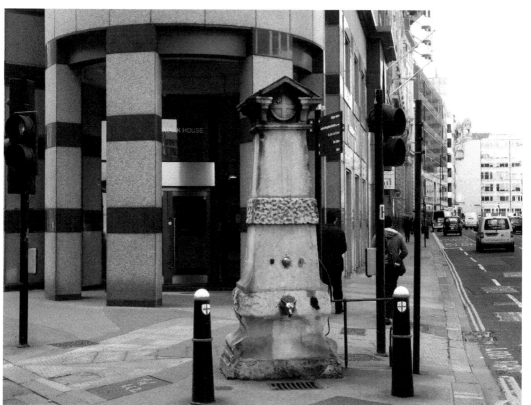

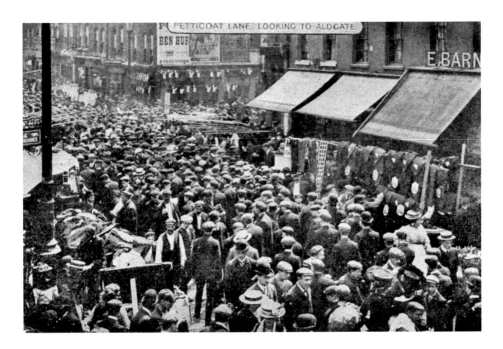

Petticoat Lane Market E1

There has been a market in the area since medieval times. By the eighteenth century the district had become well known for the manufacture of clothing. It has been the site of settlement by a number of immigrant groups, with Huguenots, followed by Jews and now Asians dominating the area at various times. The market is concentrated in Wentworth Street during the week but covers a much wider area on Sundays.

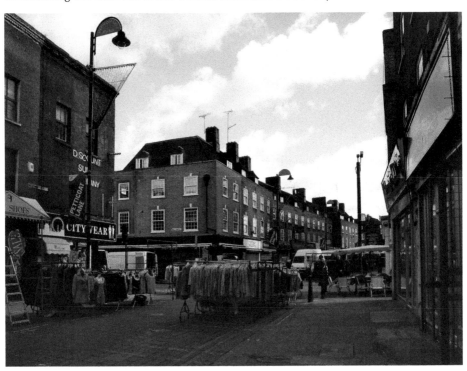

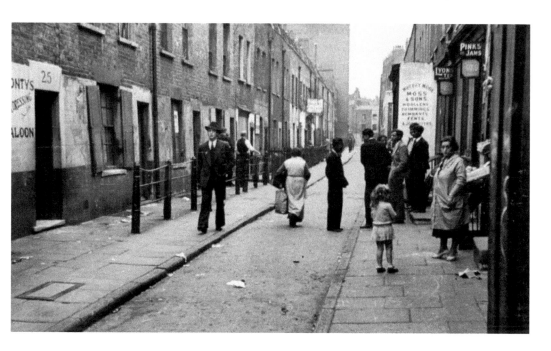

Whitechapel E1

Whitechapel was outside the old city walls of London and therefore not under the control of the city authorities. Due to this it attracted large numbers of undesirables and became known as a dangerous area. This was still the case in Victorian times when overcrowding and poverty made the area notorious. It was also the site of the 'Jack the Ripper' murders. Newer buildings, often built in the same style as those from the past, now stand amongst much older ones.

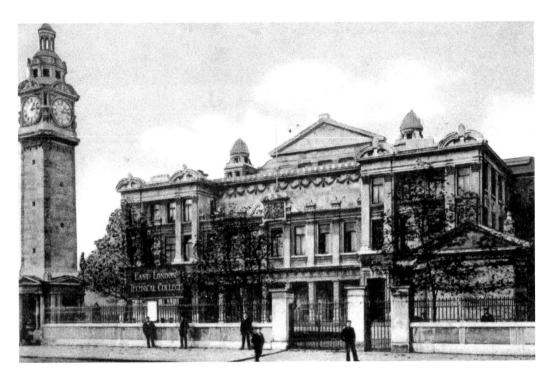

The People's Palace E1

The People's Palace stands in Mile End. It was opened in the nineteenth century for the local people and included a great hall, swimming pool, winter garden and a library. It was very popular when it opened and was visited by large numbers of people. The building is now part of the Queen Mary University.

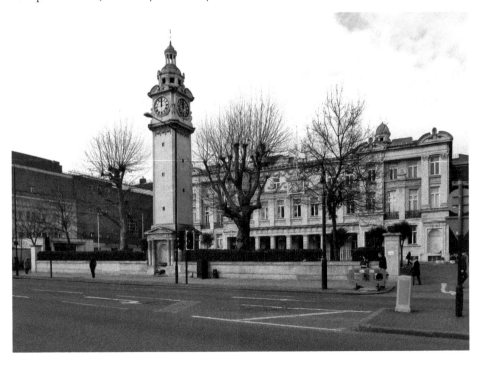

Sidney Street E1

The Siege of Sidney Street took place on 2 January 1911. It followed an attempted robbery at a jeweller's in Houndsditch by a gang of foreign anarchists. A number of police officers were shot dead during the robbery. Later, members of the gang were found in a house in Sidney Street. After a siege, involving Winston Churchill and the Scots Guards, the house caught fire and no one came out. Two bodies were then found inside. Few older buildings now survive apart from those in the photograph with much of the street taken over by industrial use.

EAST END SIEGE. — The fire at its height.

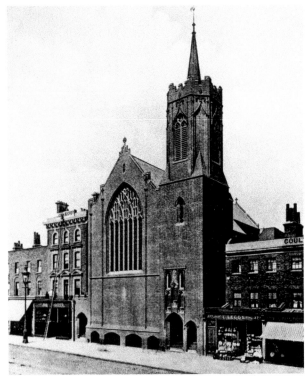

Church of the Guardian Angels E1
The site of the church was originally a Roman Catholic chapel from 1868. The present church dates from 1903. People used to gather in the church during the air raids of the Second World War. Although it may not have given much protection from bombs it must have had some spiritual comfort. The church is unusual in that it opens straight onto the pavement with no surrounding wall.

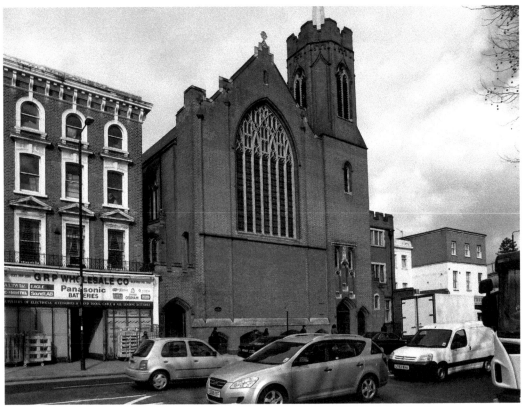

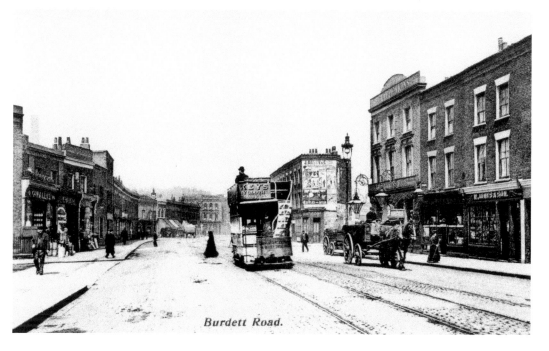

Burdett Road.

Burdett Road E1

Burdett Road is part of the A1205, which runs from Hackney to Limehouse. It runs parallel to the Regents Canal. Burdett Road was heavily developed after the Second World War, which helped to create the space for Mile End Park. Most of the buildings in the road are now from the post-war period.

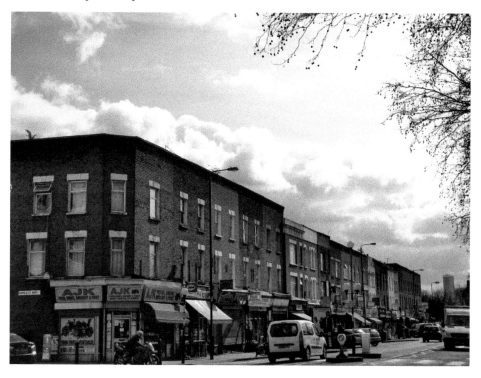

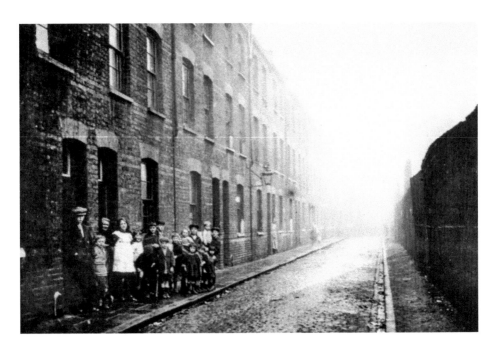

Bethnal Green E2

Bethnal Green was, until the nineteenth century, a small village outside London known for its market gardens. However, by the nineteenth century it had become overrun with slums and was full of many of London's poorest, much like nearby Whitechapel. Bethnal Green underground station was the scene of a tragedy in the Second World War, when 173 people died while rushing into the station to take shelter from air raids. Many of the streets still have terraces of old houses that must have once held poor families.

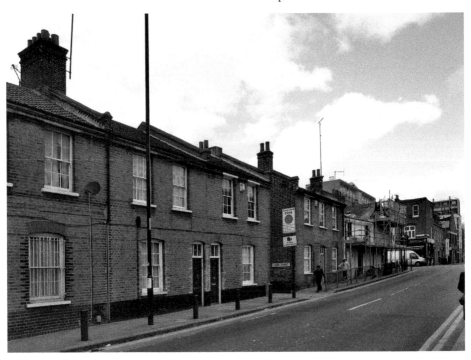

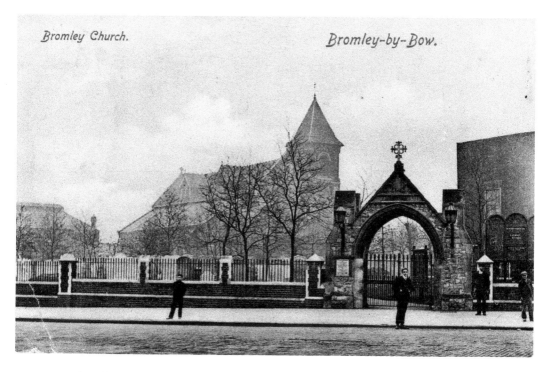

Bromley Church. *Bromley-by-Bow.*

Bow Church E3

The church was originally part of St Leonard's Priory until the Dissolution. It then became the parish church for Bromley by Bow until destroyed by bombing during the Second World War. The ruins and most of the grounds were then lost to the new Blackwall Tunnel approach road. Now only the gateway and part of the churchyard remain.

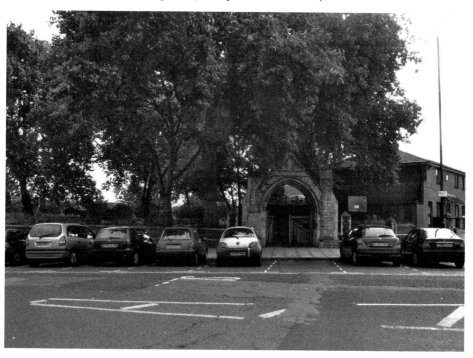

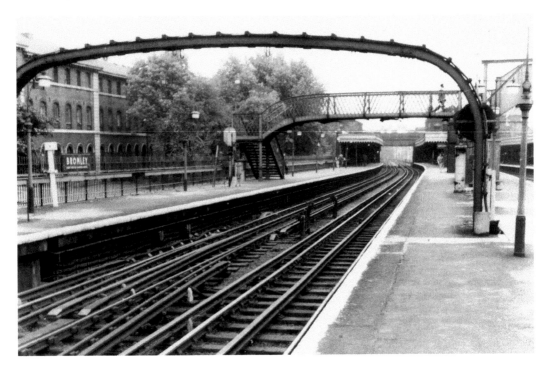

Bromley by Bow Station E3

The station was originally built in 1858 and called Bromley as the old image shows. The name changed to Bromley by Bow in 1967 to avoid confusion with Bromley in Kent. The building to the left in the old image is St Andrew's Hospital. This has now been demolished and replaced with a large housing estate.

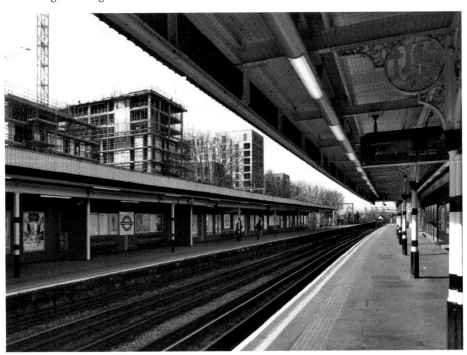

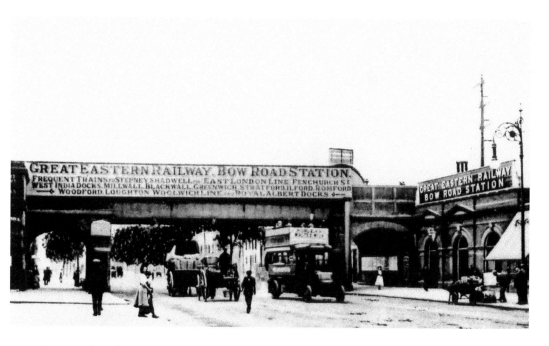

Bow Road Station

The old image shows the Great Eastern Railway station that stood in Bow until 1949. The building is now a betting shop and the railway bridge across the road is no longer in use. Bow Road station opened in 1902 and is on the District Line. It is further along the road. Just before the old station shown there is also a Docklands Light Railway station called Bow Church.

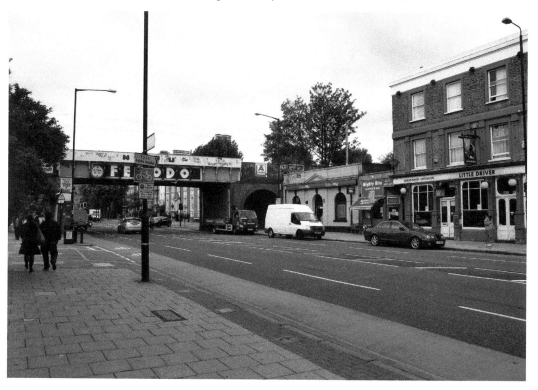

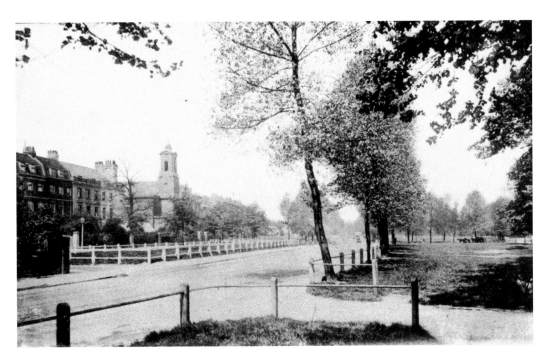

Clapton Common E5

The few houses around the area of the Common were quite exclusive in the nineteenth century. Even when the housing in that area began to expand in the latter part of the century, control over the Common was still in force. As the modern photograph shows this has changed, with the estate shown described as Clapton Common.

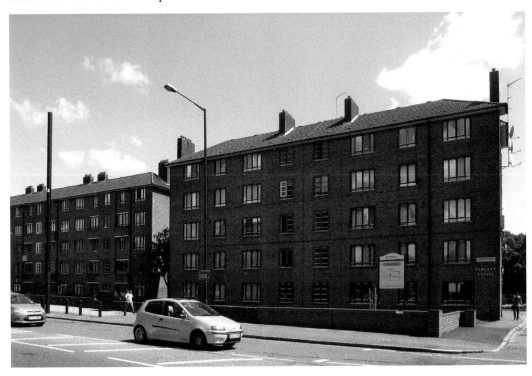

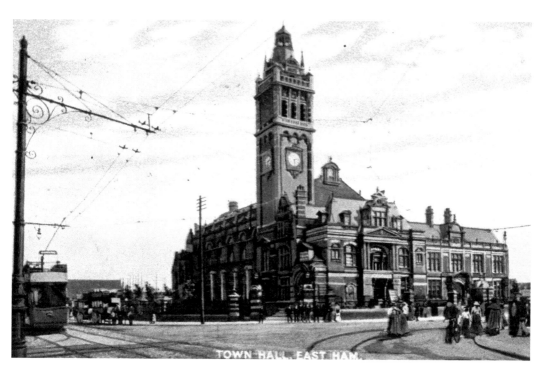

Town Hall E6

The town hall at East Ham just missed being classed as Victorian, as it opened in 1903 making it Edwardian. It was opened by a well-known local figure, John Passmore Edwards. It was the town hall for the borough of East Ham until this joined with West Ham borough in 1965 to become Newham. The building then became Newham town hall until this recently moved into more modern buildings in E16. As the modern photograph shows, the building has changed very little since its construction.

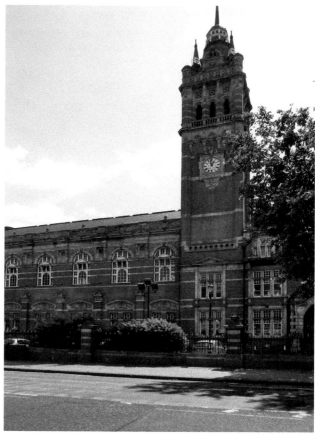

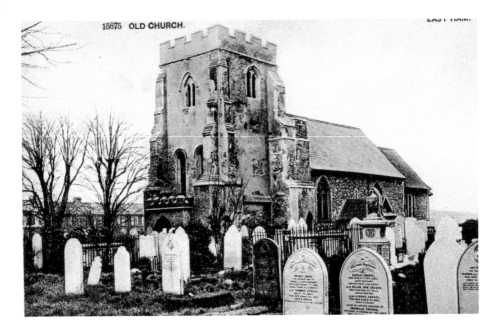

St Mary Magdaline Church E6

The old church in East Ham dates from Norman times and replaced an older wooden Saxon church on the same site. When it was built East Ham was a tiny village. Much of the building has been renewed throughout its history. The building is still in use as a church today but its ten-acre churchyard has now become a nature reserve. As can be seen from the modern photograph, the area has been allowed to grow unchecked, which has almost obscured the view of the church from the gateway into the churchyard.

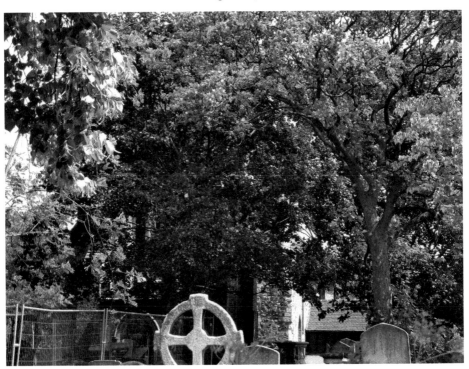

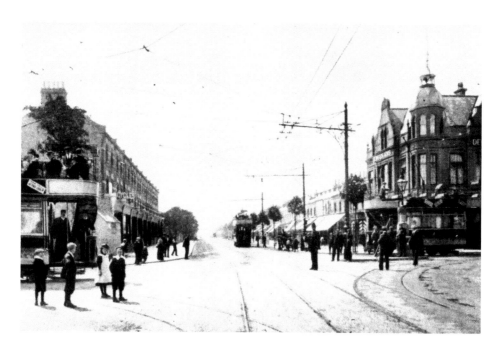

Barking Road E6

The old image shows the corner of Barking Road and High Street North, East Ham. On the corner stands the kind of public house that normally graces such main corners. This is the Denmark Arms, one of the typical large Victorian buildings common to the East End. As the modern image shows, the Denmark Arms is still open for business although it now offers more than just beer, with live football on show on its several large screens.

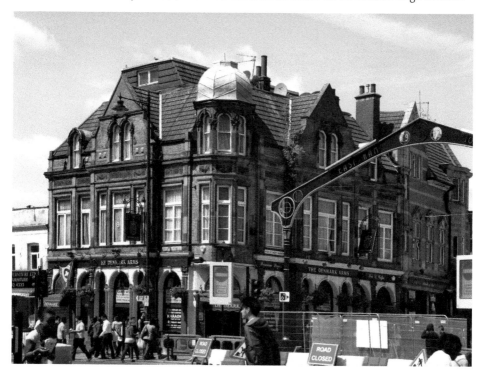

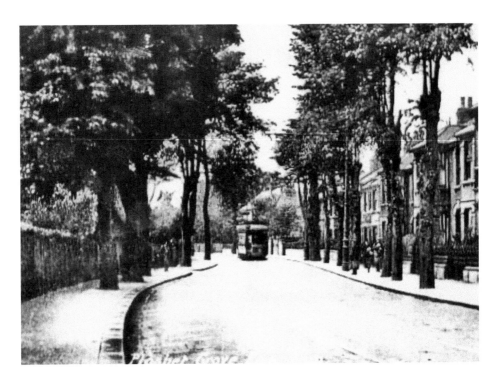

Plashet Grove E6

Plashet Grove is a busy road that runs from East Ham through to Upton Park. Although primarily a residential street, as the old photograph shows, it was an important-enough road to have a tram service. Plashet School now stands at the East Ham end of the road with a bridge overhead joining the two sites on opposite sides of the road.

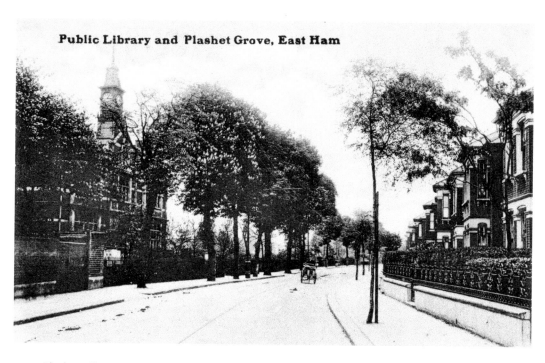

Public Library and Plashet Grove, East Ham

Plashet Library E6

The library stands in Plashet Park. As with other libraries in Newham it owes its origins to John Passmore Edwards 1823–1911. The one-time journalist, editor and MP was responsible for the origins of more than seventy buildings such as libraries, art galleries, hospitals and schools.

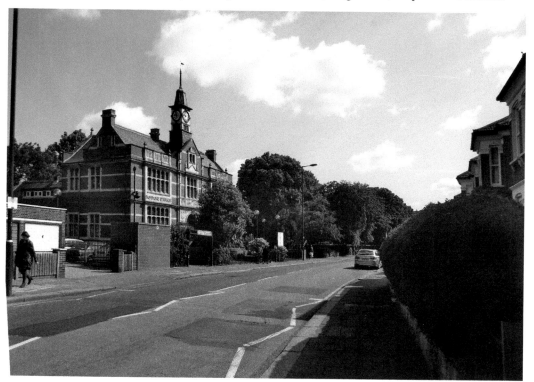

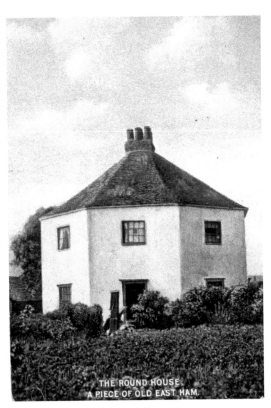

THE ROUND HOUSE.
A PIECE OF OLD EAST HAM.

The Roundhouse E6

The Roundhouse was an old octagonal cottage that stood at the end of Shrewsbury Road. It was supposed to have four families living in it. The building was demolished in 1894. The end of the road, where it meets Plashet Grove, is now full of quite modern buildings.

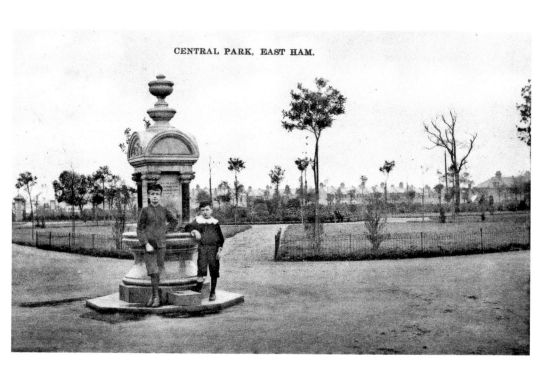

CENTRAL PARK, EAST HAM.

Central Park E6

Central Park was once part of the grounds of East Ham Hall. The land was donated for a park by the owner in 1898. The boys standing by the drinking fountain would have been old enough to take part in the First World War. Perhaps their names appear on the large war memorial that now stands in the park.

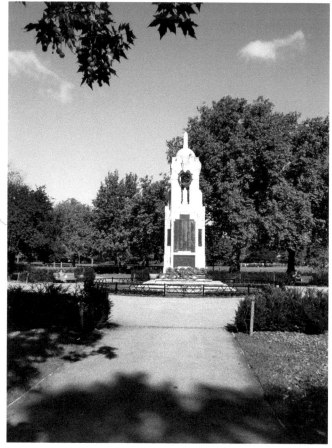

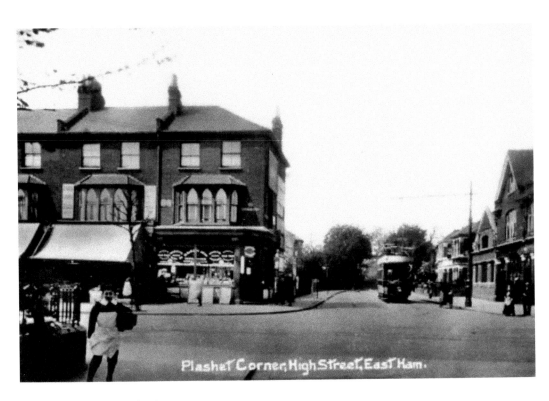

Plashet Corner, High Street, East Ham.

High Street North E6

The old photograph shows the junction of High Street North and Plashet Grove. The old public house on the right was the Burnell Arms. It was a large Victorian pub, which has unfortunately been demolished in the past few years.

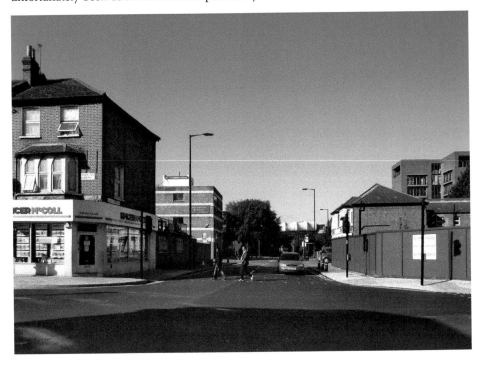

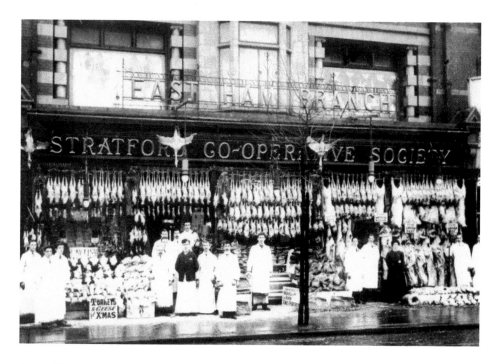

Co-op E6

The old Co-op stood in High Street North until it was demolished in 1989. There were a number of old urns from the building that were removed, and one of them is now in Central Park East Ham. There was a much more modern Co-op building in High Street North but this is now a Safeway store. There is now a small Co-op in High Street South.

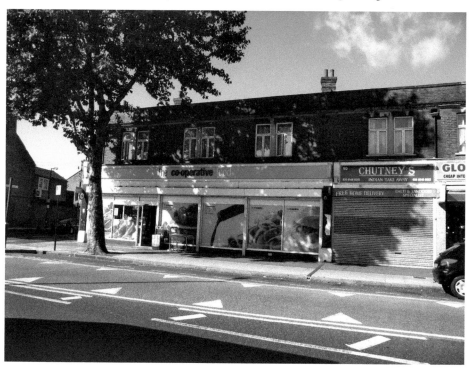

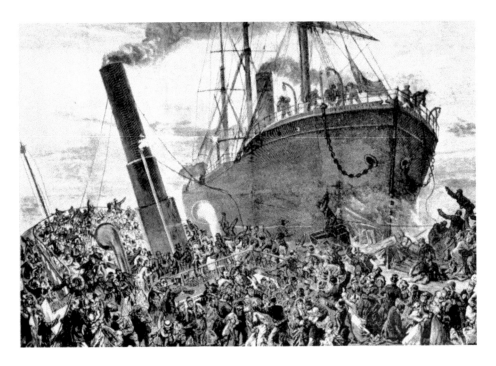

Princess Alice Disaster E6

One of the worst disasters to occur on an inland waterway happened off the sewage works and Becton Gasworks. The *Princess Alice*, a pleasure steamer, collided with a collier, the *Bywell Castle*, on the Thames in 1878. More than six hundred people died in the river, which was polluted by the outflow from the sewage works. Some survivors and bodies were taken to the nearby village of Creekmouth in Barking just across Barking Creek. Although the village has now gone, there is a plaque marking the disaster in an open space where the village once stood.

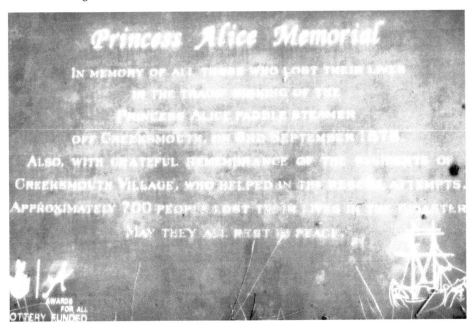

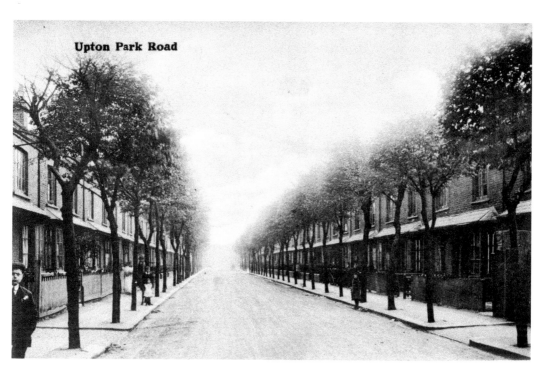

Upton Park Road

Upton Park Road E7

There seem to have been some changes to Upton Park Road since the old image was taken. One most noticeable alteration is the large modern school that now stands on the northern side of the road. No doubt this was once the site of some of the old houses in the early photograph.

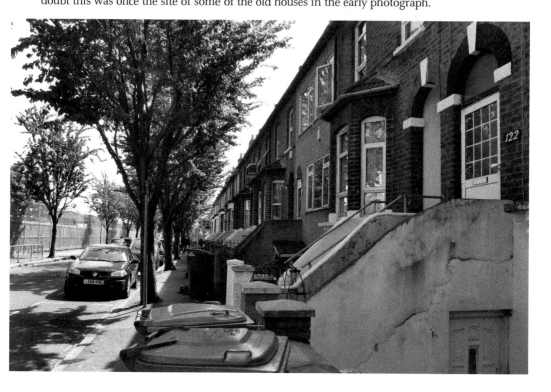

Forest Gate Hospital

The site of the hospital was originally a school until 1913. It opened as Forest Gate home for the sick and handicapped. By 1974 it had become Newham Maternity Hospital and closed in 1985. The building was used as flats but now has been replaced by Forest Gate community school.

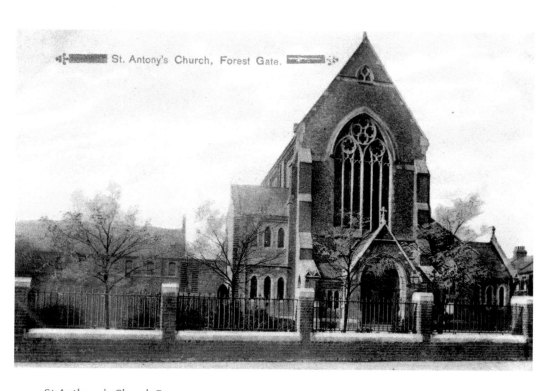

St. Antony's Church, Forest Gate.

St Anthony's Church E7

The church was built in the late nineteenth century for the Order of St Francis. It was originally their main base in the area with around fifty priests, brothers and students based there. From here they would travel out to other parts of East London and Essex.

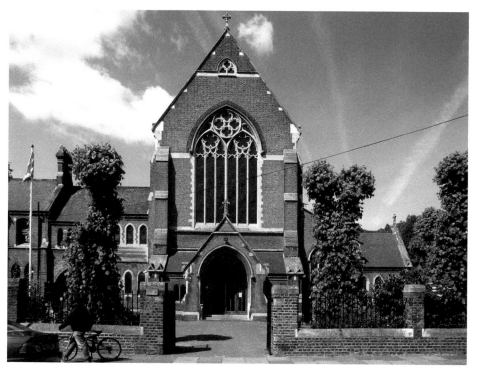

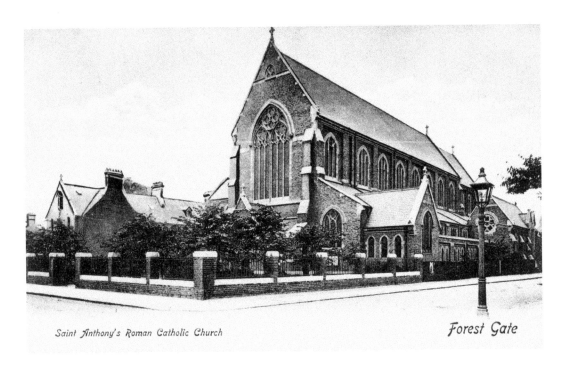

Saint Anthony's Roman Catholic Church *Forest Gate*

St Anthony's Church E7

The church itself is well attended by a very mixed congregation from a number of different countries. It was originally primarily used by Irish Roman Catholics but the population in the local area has changed over time. The use of the building attached to the church also seems to have changed as the modern photograph shows that the building is now flats.

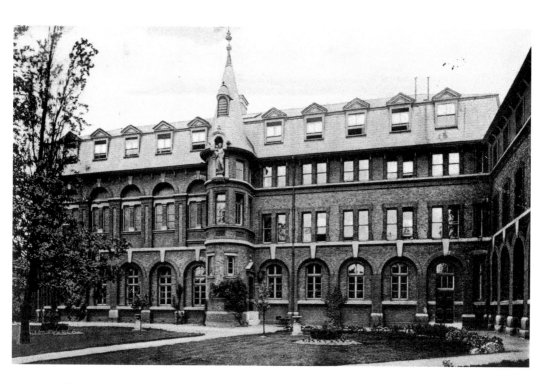

Ursaline Convent E7

The building of St Angela's Ursaline Convent has changed little since the old photograph was taken. However, it is surrounded by a large wall that restricts the view. The sisters at the site took in boarding pupils from the mid-nineteenth century and it became a public school in the early twentieth century.

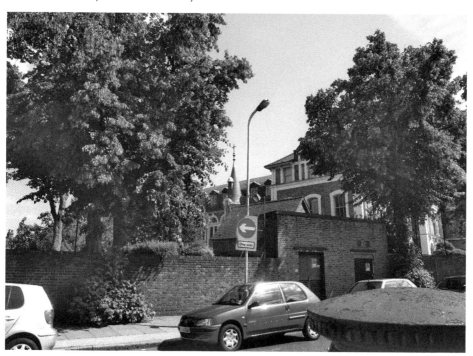

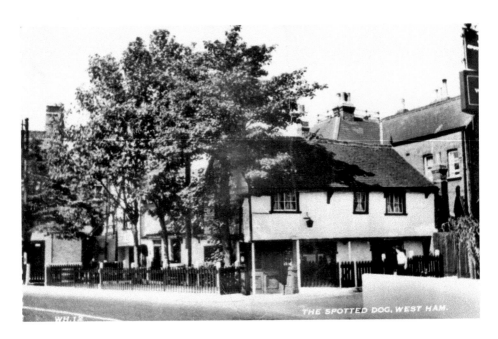

The Spotted Dog E7

The building originates from the sixteenth or seventeenth century when the area was still forest. It became an inn in the nineteenth century and was originally called The Dog. It is believed to have been named after royal hunting dogs. Parts of the building have been added throughout the centuries and until recently was a well used and popular pub. Unfortunately, as the modern photograph shows, it has now gone the way of many modern pubs and has been closed.

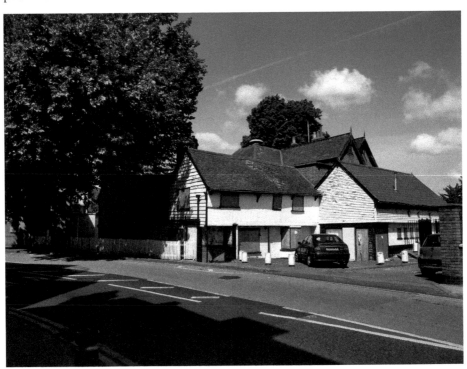

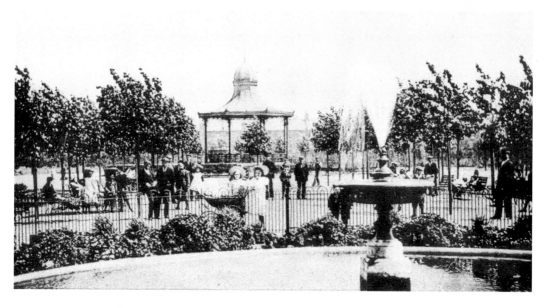

West Ham Park E7

The park has been owned by the City Of London since 1874. It consists of seventy-seven acres and is the largest park in Newham. There is also a seven-acre ornamental garden. The rest of the park provides sporting facilities, a playground and a bandstand for summer concerts.

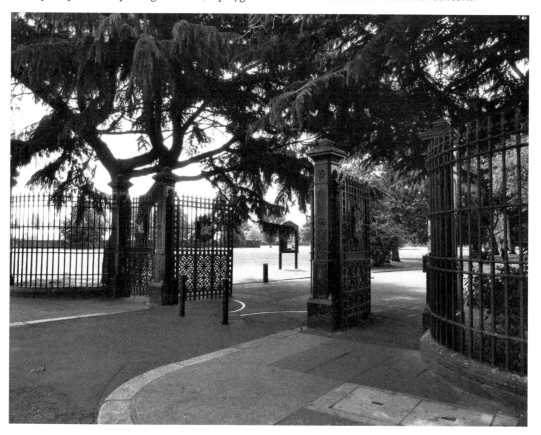

West Ham Park E7

The park used to be part of the grounds of Upton House. The land was owned by a Doctor John Fotheringill who began to build a botanical garden. He would often accept rare plants as payment of his doctor's fees. The botanical interest remains strong up until the present day.

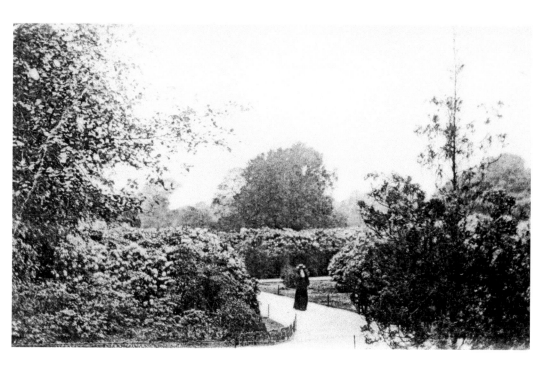

West Ham Park E7

Upton House, which stood in what is now the park, was later acquired by the Gurney family and the name changed to Ham House. The monument to Samuel Gurney still stands in Stratford today. A more famous member of the family was Elizabeth Fry, the prison reformer. While living in a house named Cedars on the estate she was visited by members of royal families from across Europe. The stone fountain marks the site of the old house.

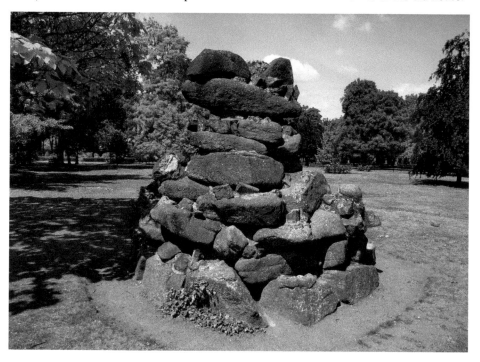

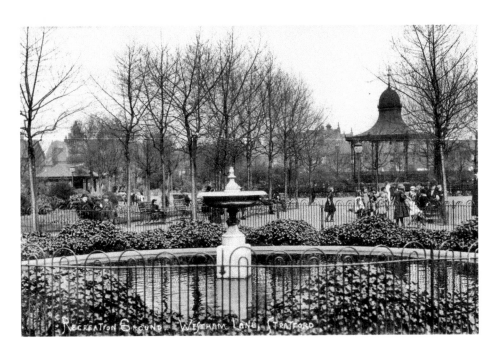

West Ham Park E7

In 1869, a man named Gustav Pagenstecher came to England as a tutor to the Gurney family. When the land attached to Ham House was sold, Pagenstecher was involved in helping to keep some of the land from being built on to create West Ham Park. He wrote a book called the *Story of West Ham Park*. Later in the First World War he was classed as an enemy alien and had to report regularly to local police stations.

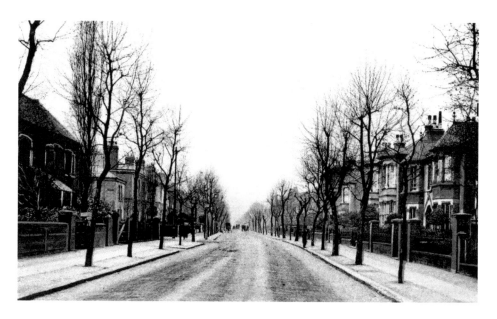

Earlham Grove E7

Earlham Grove runs alongside the railway line west of Forest Gate station. It has a number of large old houses, many of which still survive. During the First World War, a hostel for Belgian Refugees was opened in the road. Although many of the older houses survive there are also a number of newer buildings in the road as well.

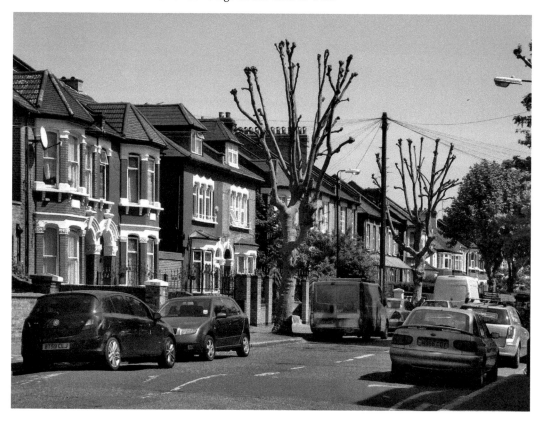

Chestnut Avenue E7

There were obviously many more trees in Chestnut Avenue in the old image. On the right-hand side of the Avenue the trees are actually in the road. The houses look quite similar but it seems as though the trees may have been removed to make the road wider, no doubt to accommodate the increase in traffic and car ownership.

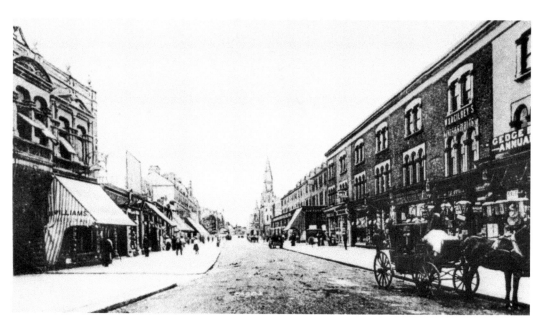

Woodgrange Road E7

The actual layout of Woodgrange Road has changed little since the old image was taken with the road still lined with shops. What the shops are selling has probably changed enormously, as have the forms of transport in use. The road must also be quite unique in having two railway stations – Forest Gate and Wanstead Park – both on different lines in the same road.

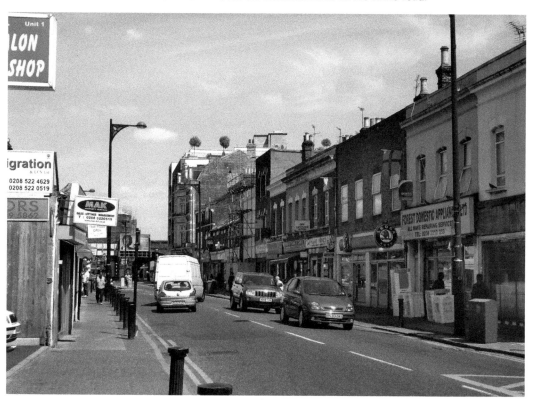

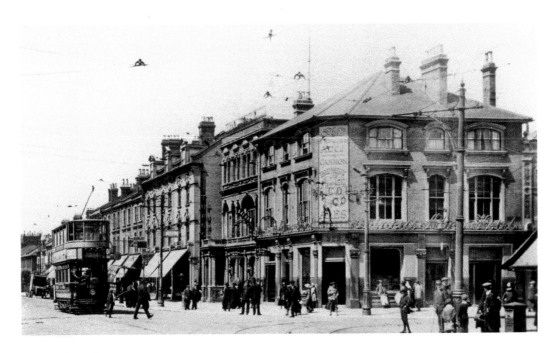

Romford Road E7

The old image shows the busy Romford Road at its junction with Woodgrange Road. The large public house on the corner is the Princess Alice. I'm not sure if this was named after the daughter of Queen Victoria or the steamboat of the same name that sank on the Thames with the loss of around six hundred lives. The pub is no longer known by the same name but many older locals still know the area as the Princess Alice.

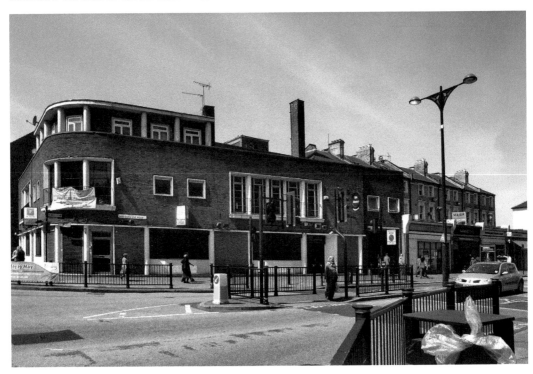

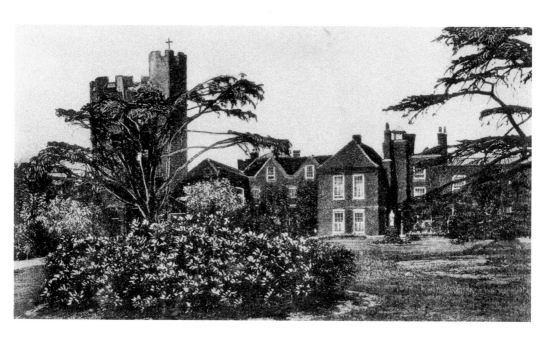

Boleyn Castle E7

Upton Park House was known as the Boleyn Castle because it was supposedly owned by or had been stayed in by Anne Boleyn. The grounds of the house were rented out by the local Roman Catholic church to a football club. The club is now West Ham United and, although more commonly known as Upton Park, the ground is actually called the Boleyn ground.

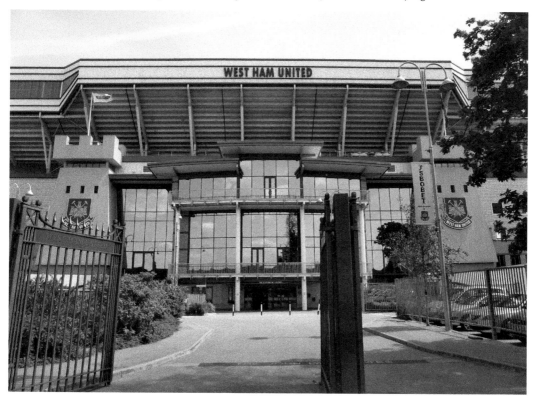

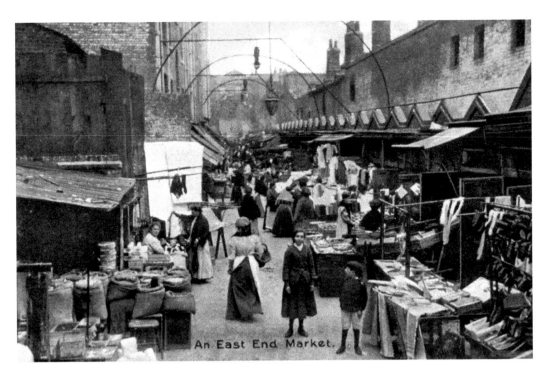

Green Street E7

The old image shows an old East End market, no doubt run by costermongers. The covered market in Green Street is a very different place today, selling very different items.

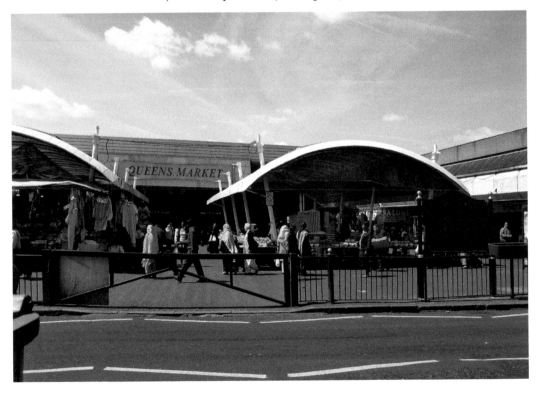

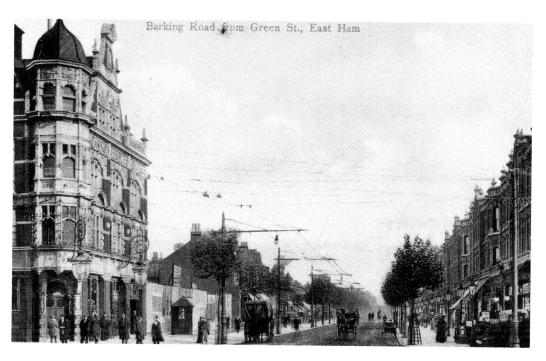

Barking Road E7

The old image shows a corner of Green Street. I suspect that it is the corner with Barking Road. If so it is an old view of the Boleyn public house, which is still there and still open. It takes its name from the Boleyn Castle, as does the nearby football ground, home of West Ham United.

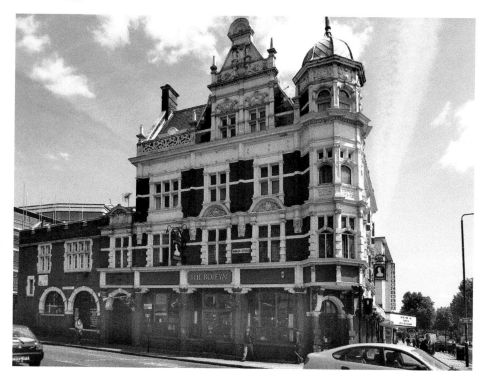

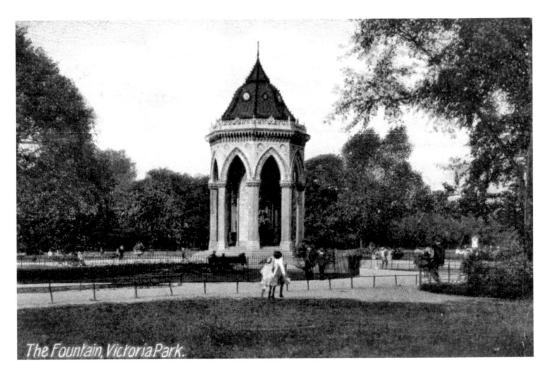

The Fountain, Victoria Park.

Victoria Fountain E9

Victoria Park is another of the large green spaces that still exist in East London. It was created in 1884. The fountain was erected due to the kindness of Angela Burdett-Coutts in honour of Queen Victoria and provided local people with drinking water. It cost £6,000, which would have built a number of houses at the time. Unfortunately, the fountain was covered in scaffolding when I took the modern photograph.

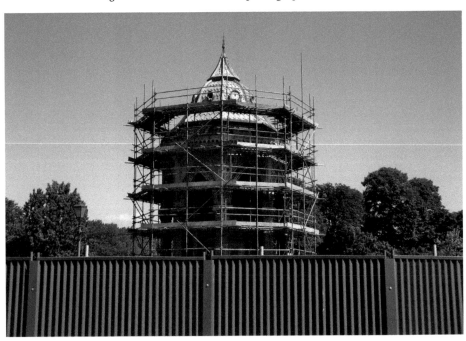

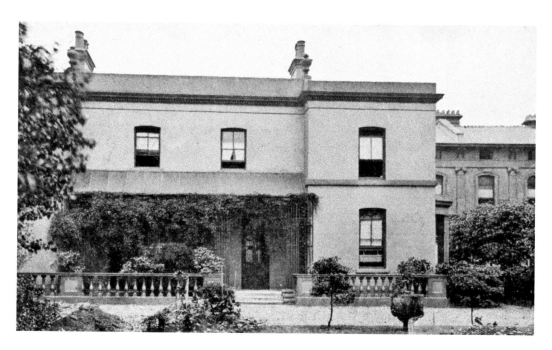

St Joseph's Hospice E9

The Hospice dates back to the turn of the twentieth century, when a Miss Grace Goldsmith gave £300 a year to a local Catholic priest, Father Gallway. Joined by five nuns from Ireland, the work of the hospice began. As can be seen from the modern photograph, the hospice has expanded dramatically since the old image was taken.

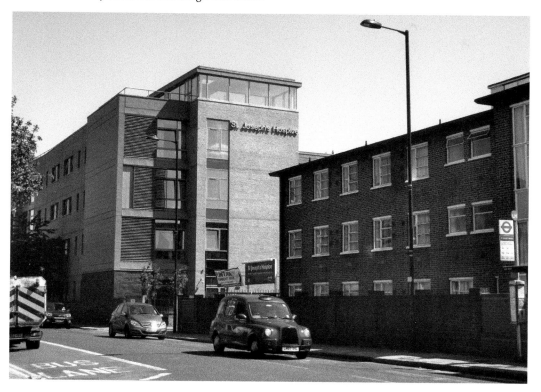

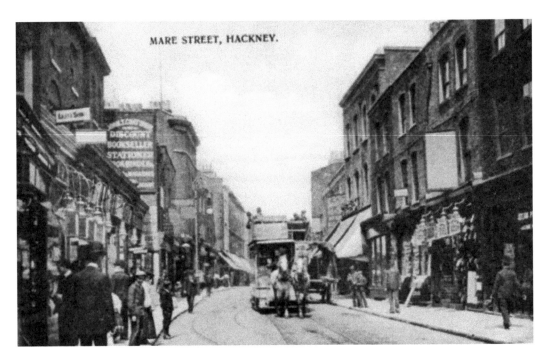

MARE STREET, HACKNEY.

Mare Street E9

Mare Street marks the site of what was once Hackney Village. Many of the buildings in the old image owe their origins to the nineteenth century, especially after the railway arrived in the 1850s. Although some of the old buildings survive, many new ones have been added to the busy road.

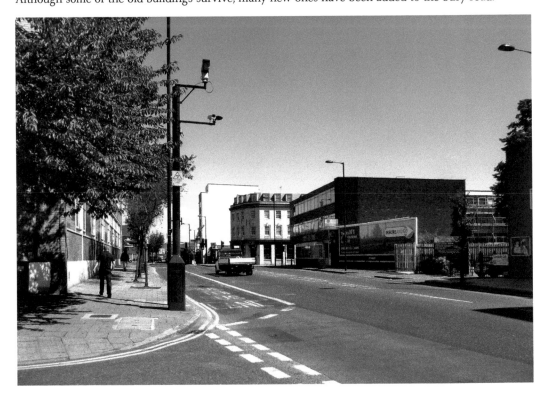

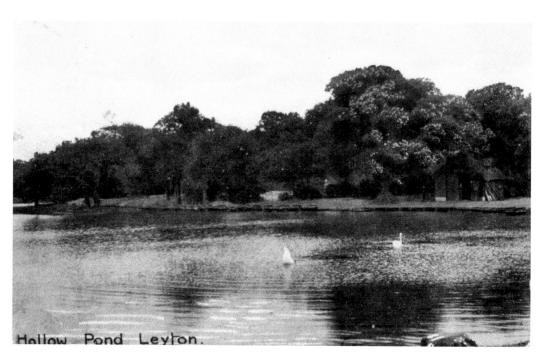

Hollow Pond Leyton.

Hollow Pond E10

The Hollow Pond is one of the ponds on Wanstead Flats. The area was once part of Epping Forest and has remained as open land despite the building that has gone on all around it. The Hollow Pond is one of the larger lakes on the flats and is a haven for wildlife. It is also used as a boating lake; however, some unsightly scaffolding has been erected around the boating area, which has not improved the site.

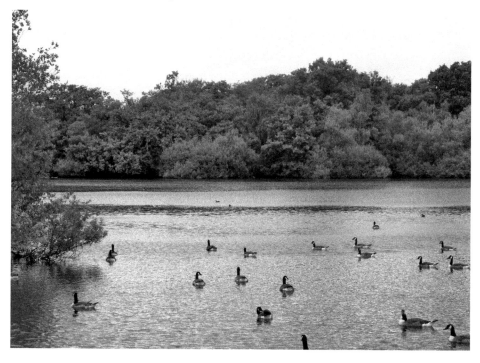

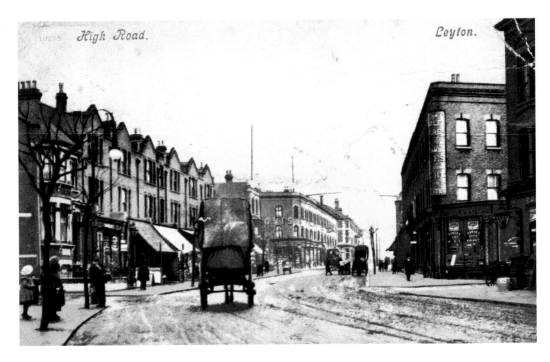

High Road E10

High Road Leyton runs from Walthamstow in the north down to Stratford in the south. It has two railway stations, Leyton Midland Road on the Barking to Gospel Oak line and Leyton on the Central line. Leyton Orient Football ground also lies just off the main road. As with most other main roads in the area it has a variety of old and new buildings alongside each other.

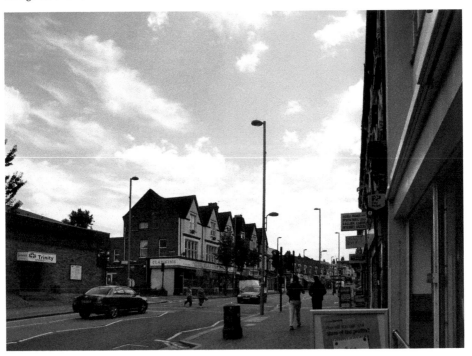

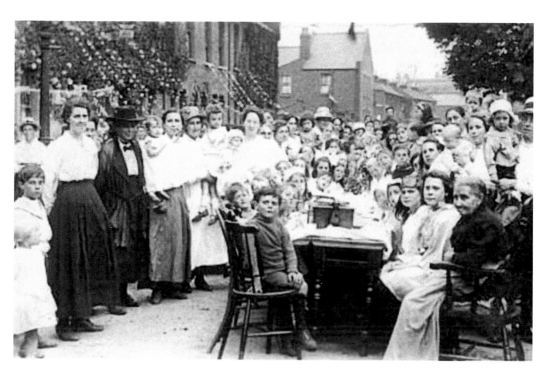

Victory Party E10

Victory parties were held all over the country after the end of the First World War. This one was held somewhere in Leyton. As can be seen from the modern photograph the houses have changed little since the war. The cars outside and no doubt what is in the houses must be very different.

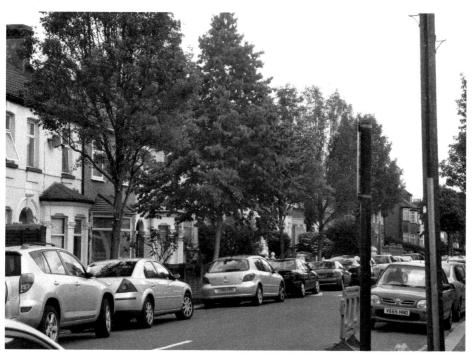

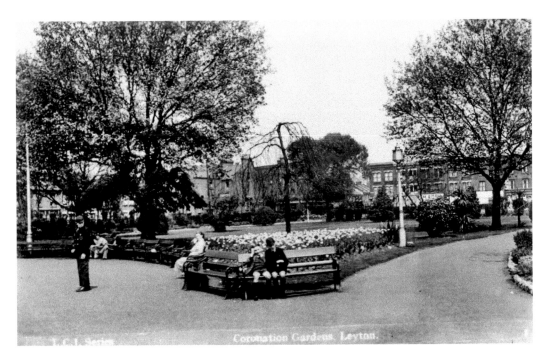

Coronation Gardens

The park got its name from the fact that the land was purchased in 1902 when Edward VII was crowned. The park opened in 1903. The fountain dated from the 1920s but was replaced in 2000.

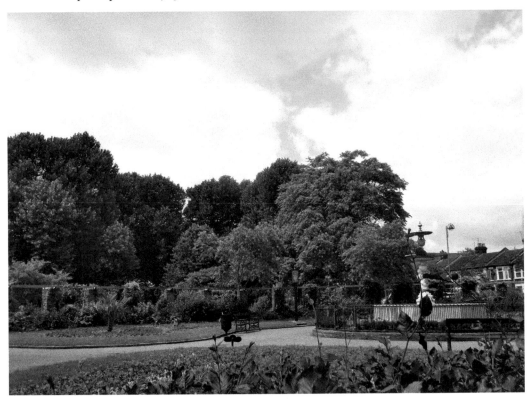

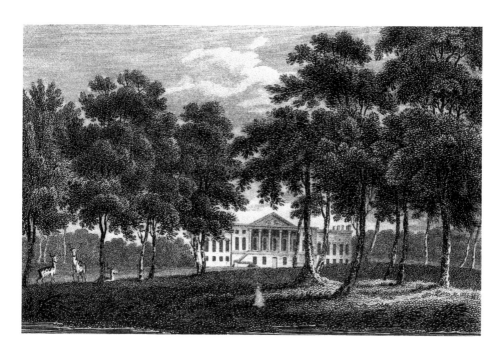

Wanstead House E11

Wanstead House was built in 1715 and was one of the grandest houses in the area that is now East London. However, it was short lived after falling into the hands of a member of the family of Lord Wellington in the early nineteenth century. It was demolished after the contents were sold off to pay the debts of the owner. The largest building in the area now is Snaresbrook Crown Court. Surrounded by tress only the top of the towers can be seen from Wanstead Flats.

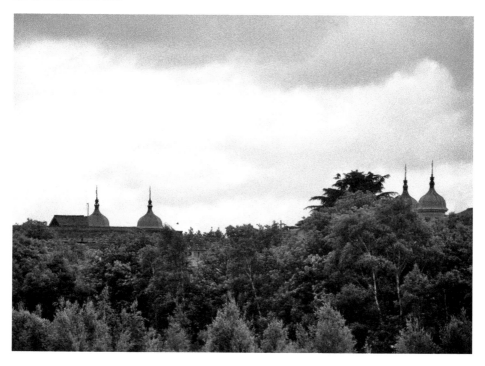

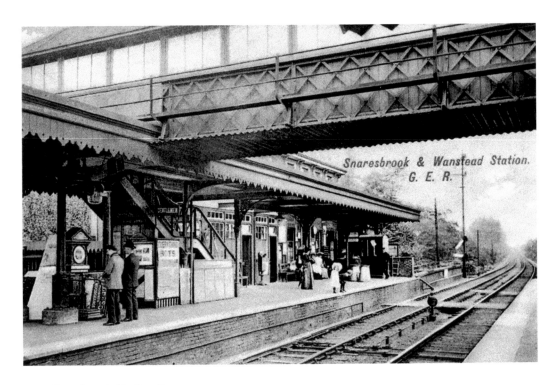

Snarsbrook Station E11

The station at Snarsbrook is one of the older stations in London and opened in 1856 on the line from Loughton to London. As the old image shows, it was once known as Snarsbrook and Wanstead station. Wanstead now has its own station. Snaresbrook station is probably best known by those travelling to the nearby Crown Court.

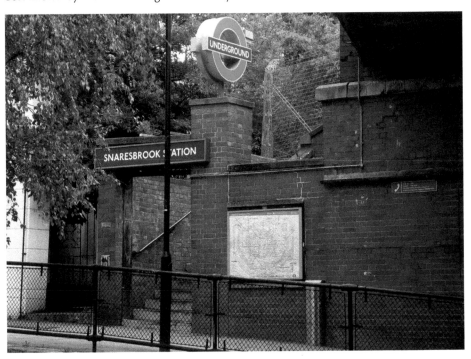

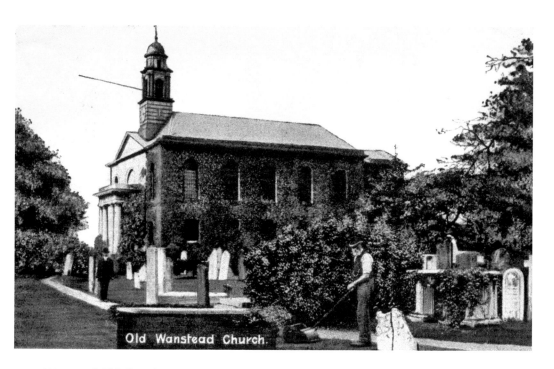

Old Wanstead Church.

Wanstead Old Church E11

The church of the Virgin Mary at Wanstead was built between 1787 and 1790. The church was paid for by Sir James Tyiney-Long. It has changed little in that time except that due to the growth of tree it is impossible to take a photograph from the same position as the old image.

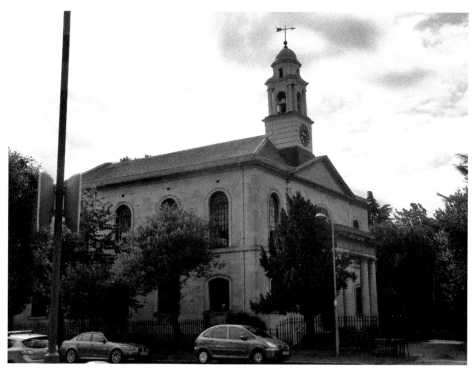

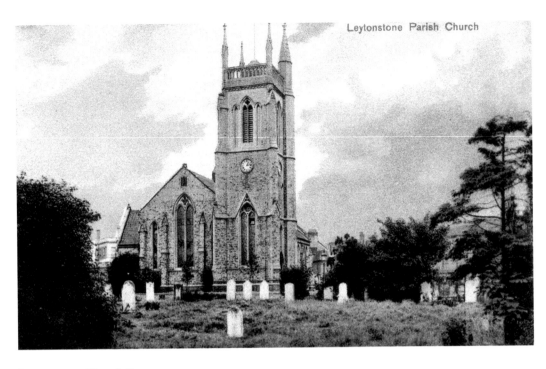

Leytonstone Church E11

Leytonstone once came under Leyton parish until a small chapel was built for the villagers. The church of St John the Baptist replaced the chapel in 1832. As can be seen from the modern photograph, little has changed about the church since the old image was taken.

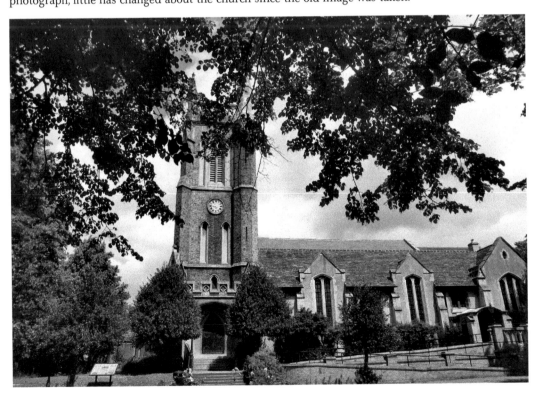

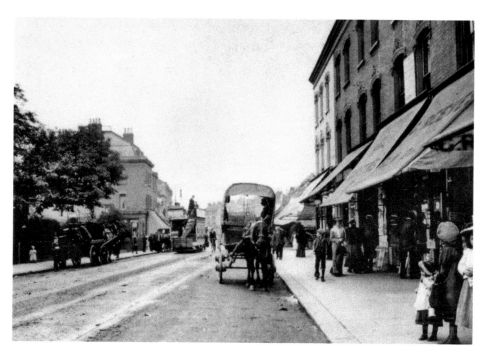

High Road E11

Leytonstone High Road is very similar to other high streets in East London. It was a busy shopping centre in the past and that has not changed. However, the shops have and so has what they sell. The customers have also changed with the area being the home of high numbers of immigrants of many nationalities.

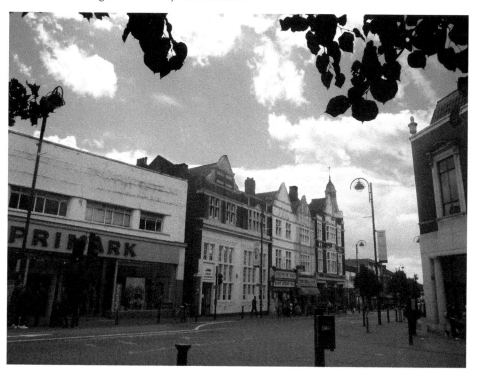

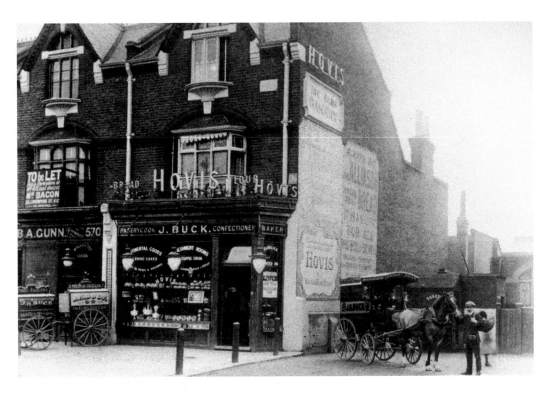

High Road E11

Although the road is similar to other High Streets, there are parts of the road where the flats above the shops have become very run down. However, the situation varies and some parts of the road are residential with some very nice well-kept houses.

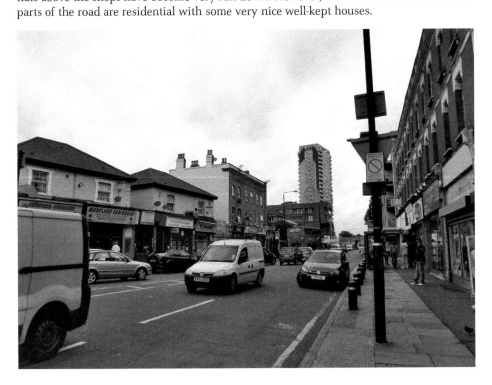

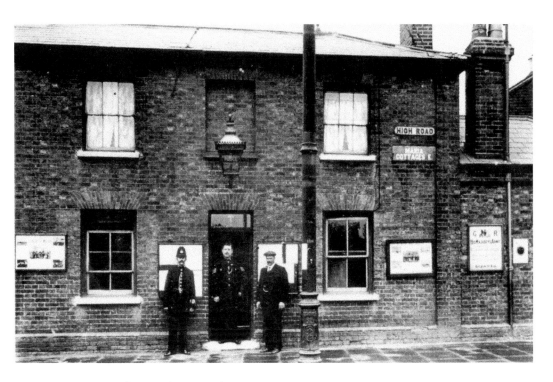

Leytonstone Police Station E11

The police station in the old image was later replaced with the building in the modern photograph. This building then closed in 2007 due to centralisation of the service. The building has recently been occupied by squatters but is to be sold for development.

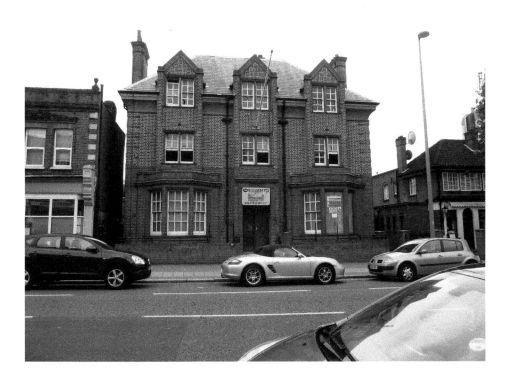

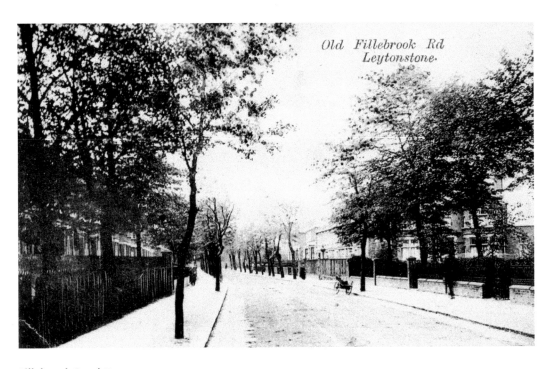

Old Fillebrook Rd Leytonstone.

Fillebrook Road E11

Part of the old Fillebrook Road disappeared when the new road was built next to Leytonstone underground station, from where the modern photograph was taken. It is now difficult to find anything that resembles the old street.

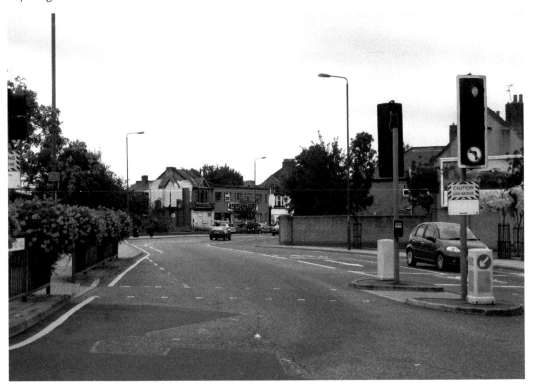

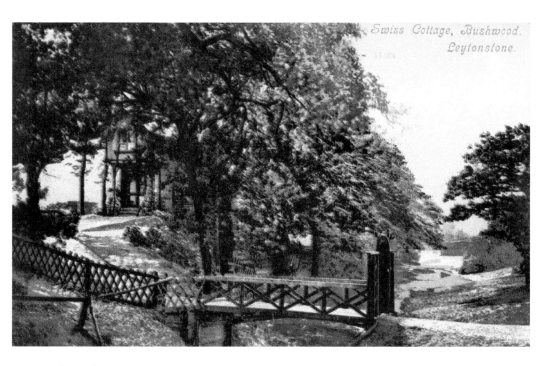

Swiss Cottage, Bushwood.
Leytonstone.

Bushwood E11

There was an unusual wooden-framed Swiss cottage on the southern edge of Bushwood dating from around 1850. It stood in the grounds of Lake House and was reached by a bridge across a ditch. The building was demolished in 1962.

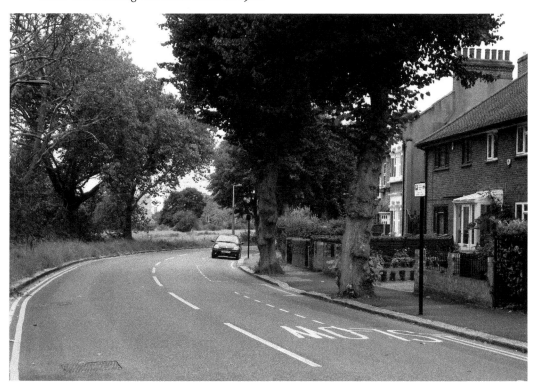

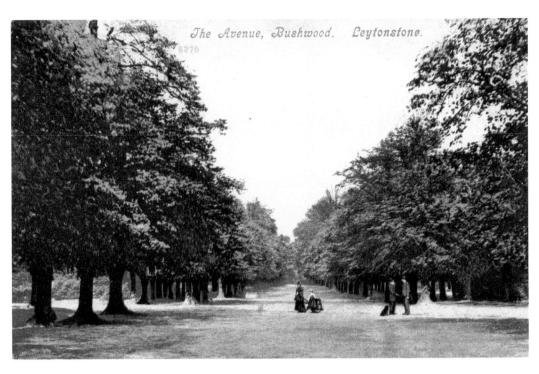

The Avenue, Bushwood. Leytonstone.

Bushwood E11

Bushwood is a large, wooded area in Leytonstone. It is joined to Wanstead Flats but is seen as a separate area from the flats. A road also called Bushwood runs along the edge of the area with houses only on one side overlooking the wooded area.

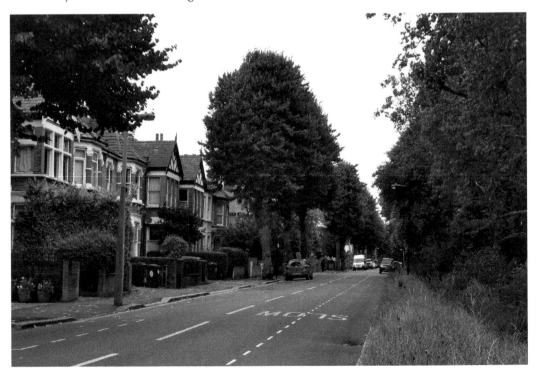

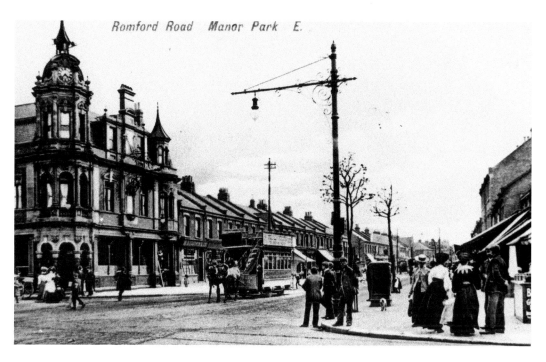

Romford Road E12

The building on the corner is a large Victorian public house common to the corners of busy streets in East London. This one is on the corner of High Street North and Romford Road in Manor Park.

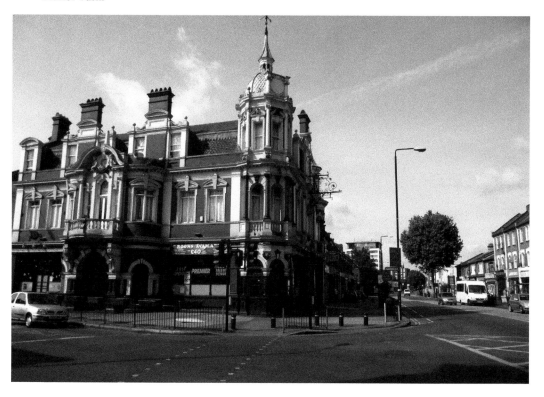

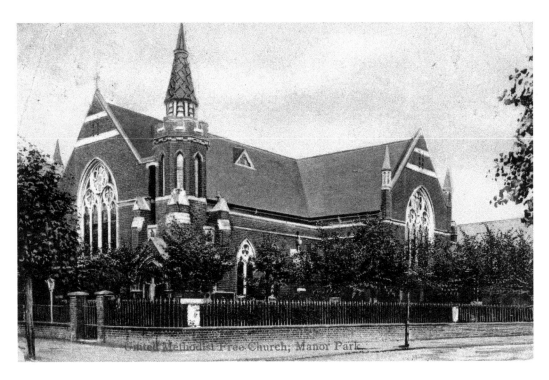

Methodist Church E12

The main structure of the church seems to have changed little over the years apart from an extension being built on the side. The church is now Manor Park Christian Centre, which seems to incorporate a number of different churches.

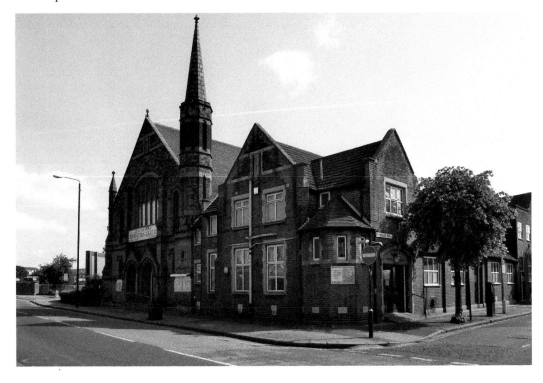

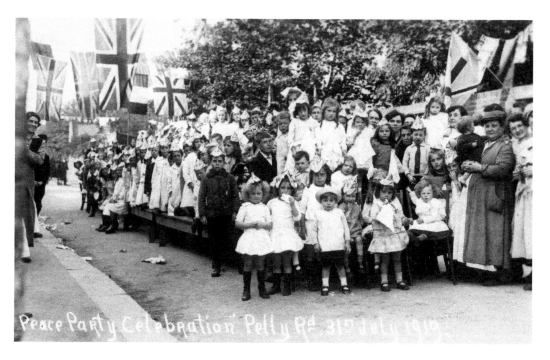

Peace Party Celebration Pelly Rd 31ˢᵗ July 1919

Pelly Road E13

When the celebrations took place after the First World War, Pelly Road was a very different place to what it is today. The road was then like most others in the area and consisted mainly of small terraced houses. As the modern photograph shows there is nothing left of these today, as the road is now almost entirely full of modern flats.

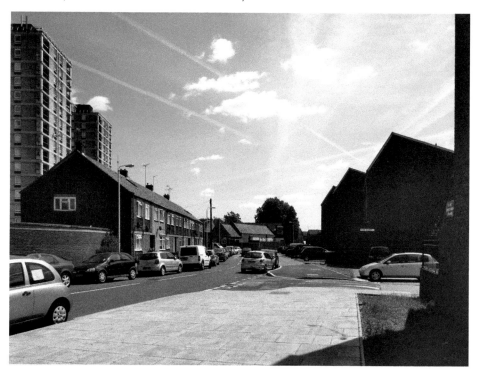

St Mary's Children's Hospital E13

One big difference between health care in the past and present is the number of small hospitals that existed in East London at the turn of the century. The more modern method is to build much bigger hospitals to serve a wider area. The children's hospital in the old photograph stood in Howard's Road. There is still a medical connection in the road with the ambulance station shown.

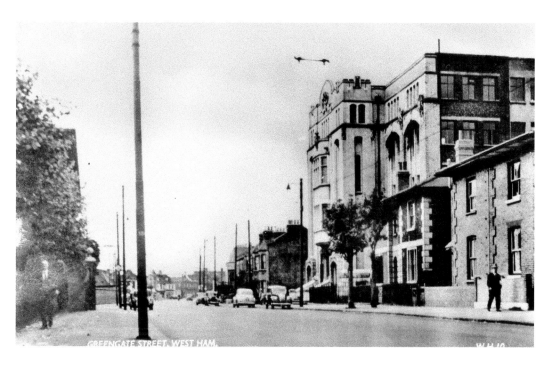

Greengate Street E13

The large building on the right of the old photograph was once a YMCA club. In more recent times it was also an annex of the Polytechnic of East London, later the University of East London. It has now been converted into flats but the exterior has changed little despite the modernisation of the interior.

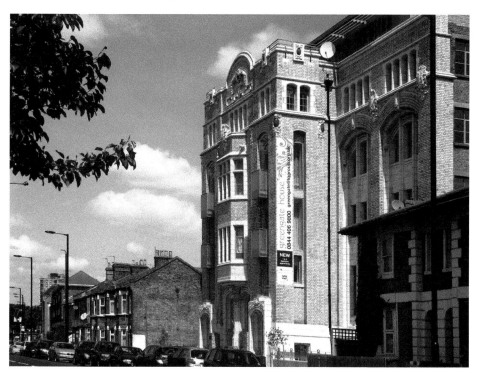

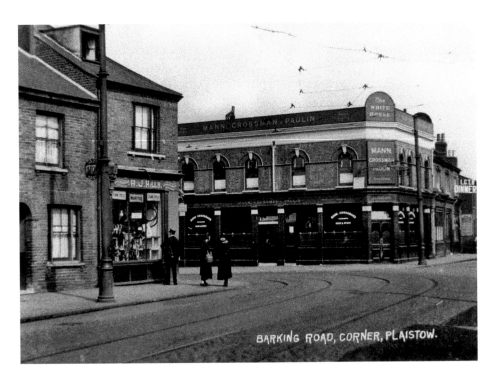

BARKING ROAD, CORNER, PLAISTOW.

Barking Road E13

Another old image of a corner at Barking Road, Plaistow with a pub on the corner. This seems to be called the White Horse but I can't find any record of a White Horse in Plaistow. The modern photograph shows a corner with Barking Road and the side view of the Greengate.

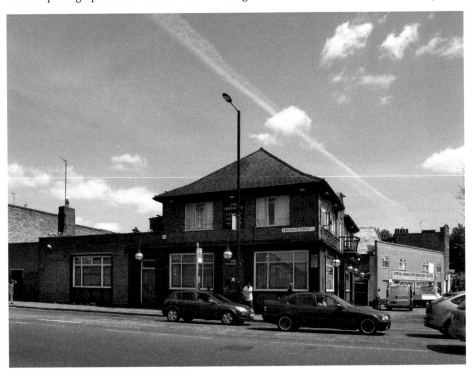

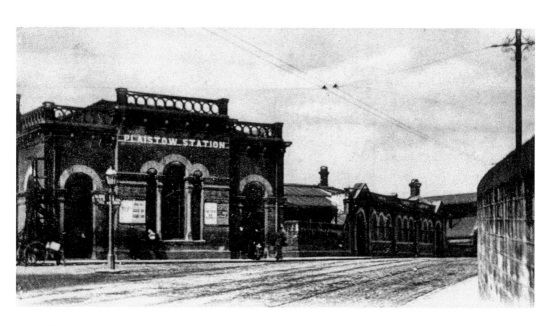

Plaistow Station E13

Plaistow station was opened in 1858 by the London, Tilbury & Southend Railway. In 1902 the District line began to run through the station. There were large sidings next to the station but these are now covered by a car dealership. As can be seen there has been little change from the old to the new image.

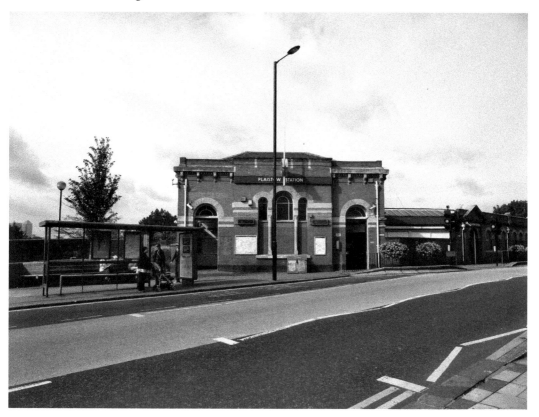

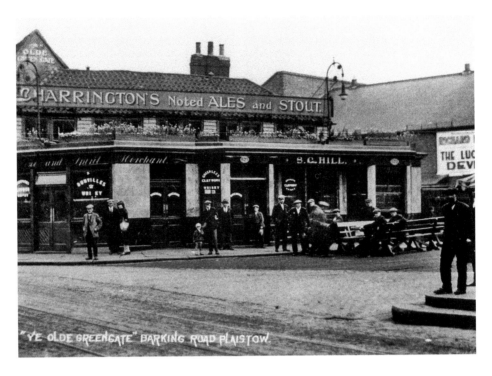

The Greengate E13

The old image of the Greengate shows a smaller pub than its modern counterpart with only one storey. The large area in front of the building is still there and is now used by a fruit seller. The pub itself has obviously been rebuilt at some time in the past.

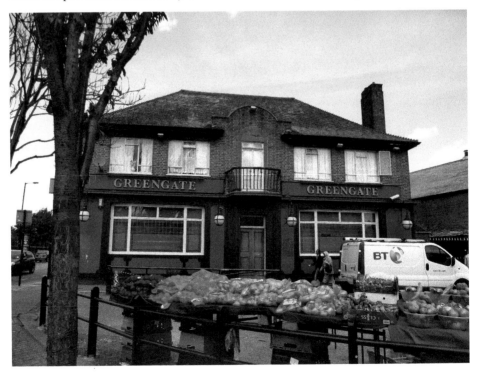

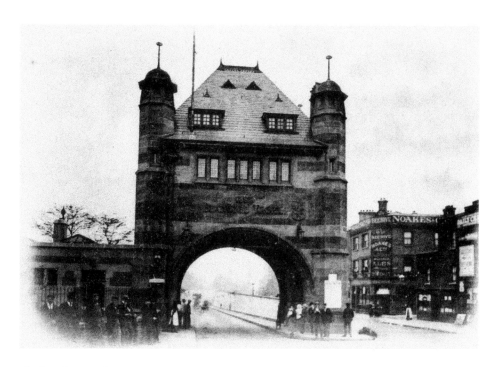

Blackwall Tunnel E14

The tunnel was built between 1892 and 1897, and seven men died during its construction. The area around the tunnel is unrecognisable compared to that of the old photograph. Large new buildings line the road either side of the tunnel entrance. The modern photograph shows the buildings with the tunnel approach between them. This was taken from Blackwall Docklands Light Railway Station.

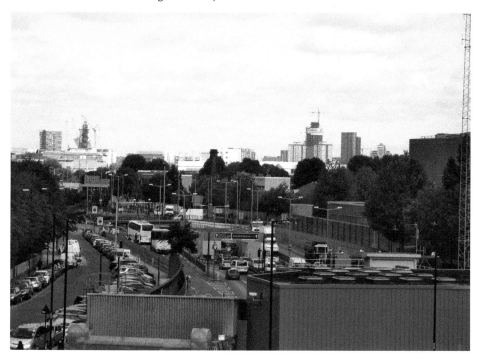

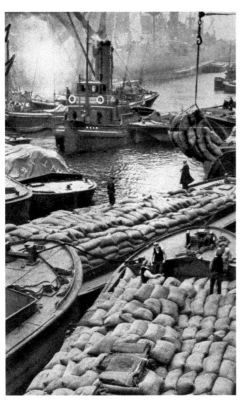

London Docks E14

The London docks at their height stretched along the Thames through the whole of East London. They were the busiest docks in the world. Today they are covered in new buildings and the City Airport. There are some areas still used for water transport such as this marina in Poplar.

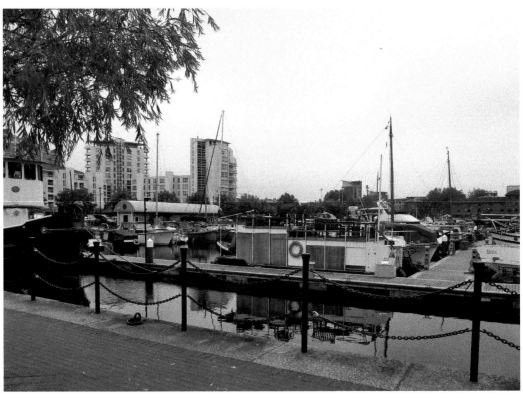

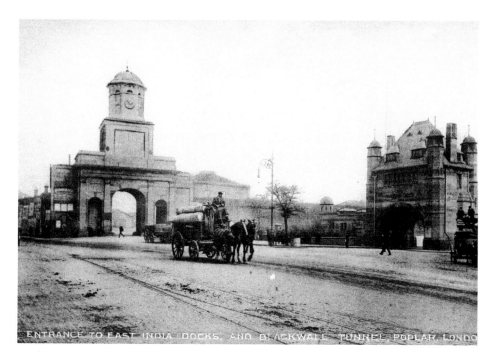

East India Docks E14

The old image shows the grand entrance to the old East India docks and the Blackwall Tunnel entrance. The area has changed so much now, along with the rest of docklands, that it is almost unrecognisable. The modern photograph shows several large buildings now dominating the river bank.

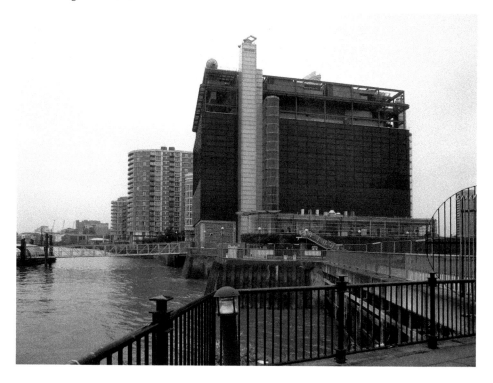

London & Blackwall Railway E14

The London & Blackwall Railway ran from the Minories to Blackwall and the Isle of Dogs from 1840 to 1926 for passengers. It carried on being used for goods until 1968 and closed as the docks declined. As the old photograph shows, some of the line was raised above the ground, very similar to its replacement, the Dockland Light Railway.

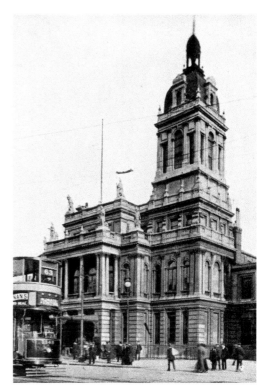

Town Hall Stratford E15

The town hall itself has changed little since the old photograph was taken. Opened in 1869 it was extended in 1884. It was later restored after a fire in the early 1980s.The people in the old image would recognise much less of the area now, especially as it is being prepared for the 2012 Olympics.

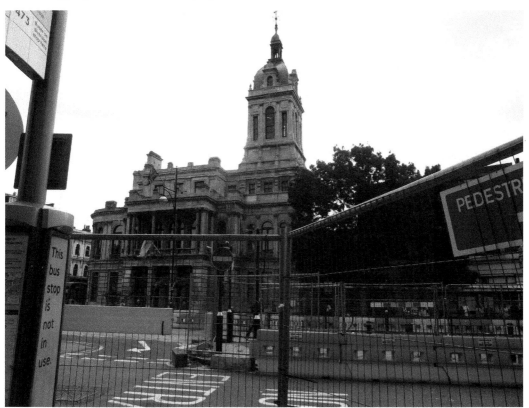

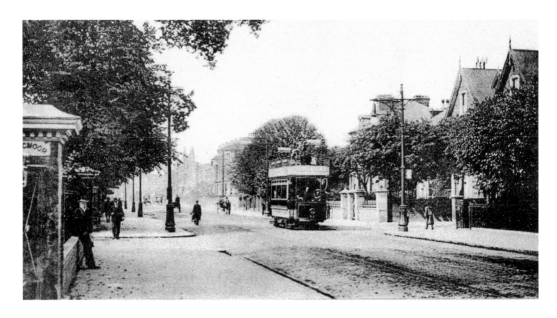

Romford Road Stratford E15

Many of the large old houses in Romford Road do survive, although a majority are now hotels or converted into flats rather then being single family homes. Alongside these stand much more modern buildings such as blocks of flats and office buildings. Buses have also replaced the trams and the traffic is much busier.

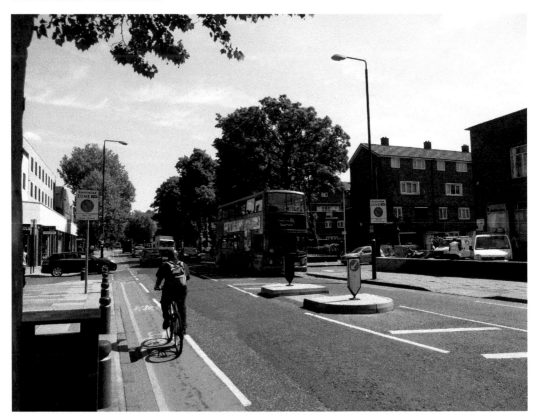

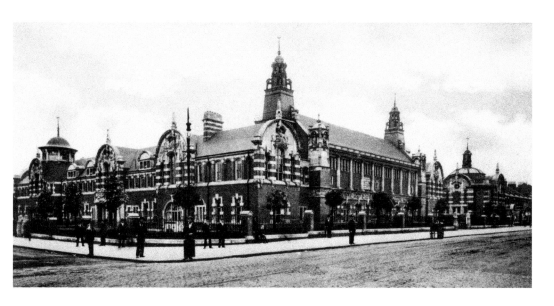

The Technical Institute Stratford E15

The Technical Institute was opened in 1892. Speaking at the opening it was called a 'people's university' by John Passmore Edwards. His words were to have a ring of truth but much later on into the future. The far right of the building was once the Passmore Edwards Museum. The left of the building was once the local library. The building later became part of the University of East London.

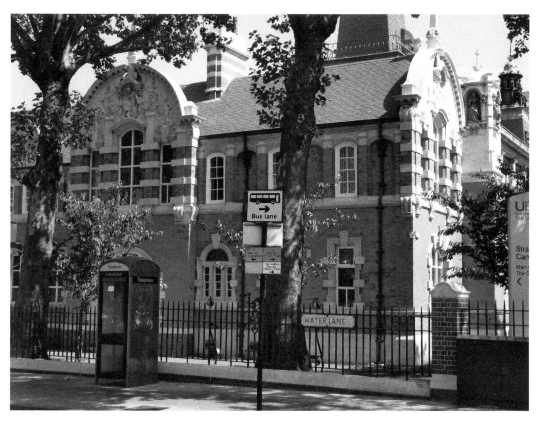

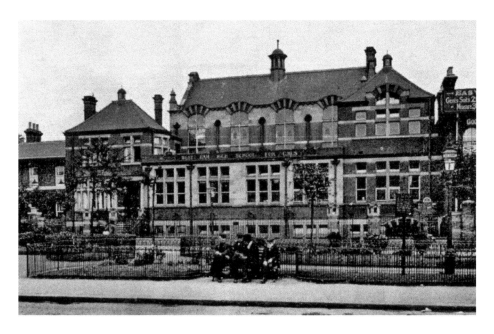

Water Lane School Stratford E15

The school opened in 1897, sporting a centre for deaf and dumb children, school board offices and a teachers' centre. In 1937 it became a school for senior girls, and junior and infant boys. It became a mixed secondary school in 1945 and was renamed Stratford Green School. The boys were transferred in 1958 leaving it as just a girls' school. The building is now part of Sarah Bonnell girls' secondary school.

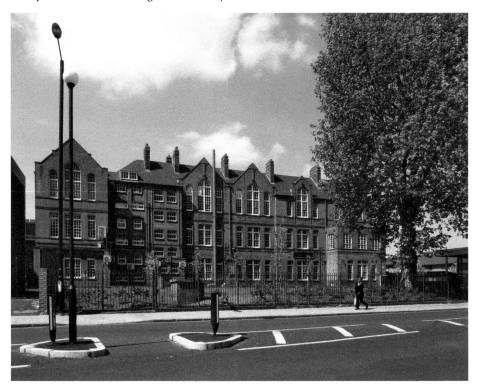

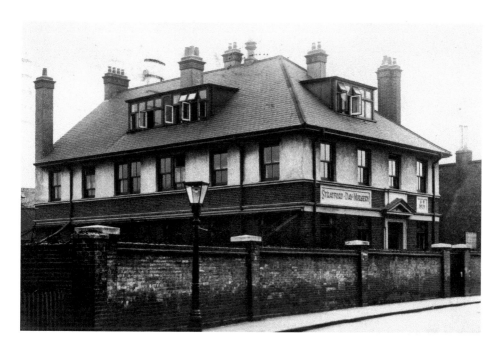

Stratford Day Nursery E15

I thought that nursery schools were quite rare before the Second World War. The old image shows a day nursery in Stratford in 1932. There were, in fact, two nursery schools that opened in the town in 1930: Rebecca Cheetham and Edith Kerrison. The recent image shows a much more modern idea in the town. The Children's Story Centre caters for children from all areas.

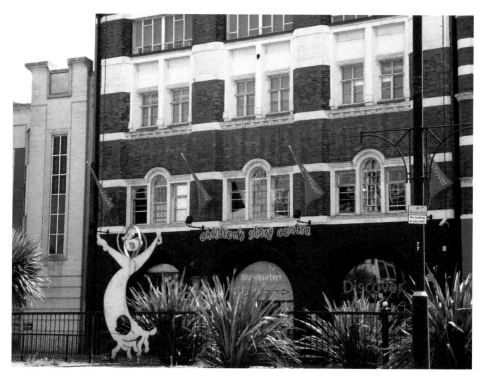

Temple Mills E15

Temple Mills was an area behind Stratford station, which began life as the Great Eastern Railway Works in 1850. It continued as a railway area until most of it closed in 1991. The rest closed in 2007 and the area has now been amalgamated into the new Olympic Park, Stratford International Station and the more recent Westfield Shopping Centre.

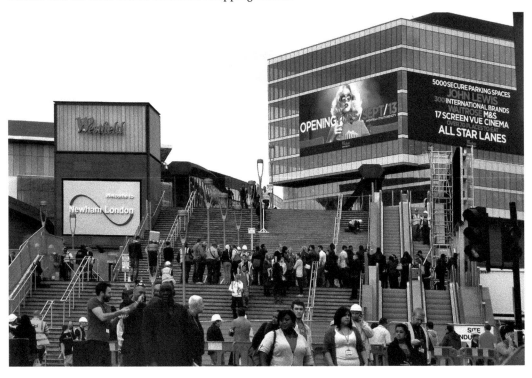

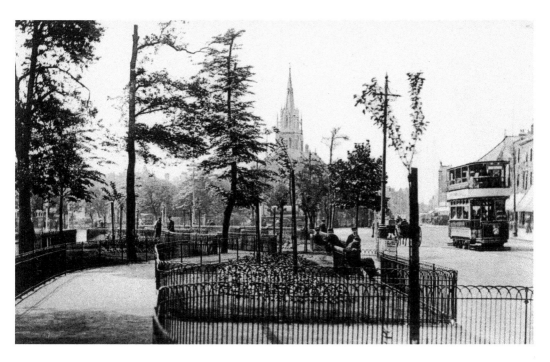

The Grove E 15

The Grove has changed significantly since the old photograph was taken. The church is now almost obscured by trees. The shops are still to the right but are obviously very different now.

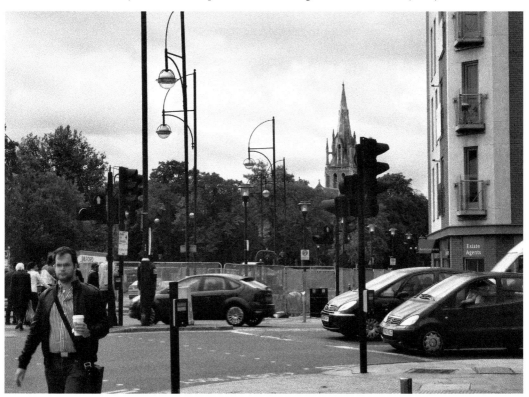

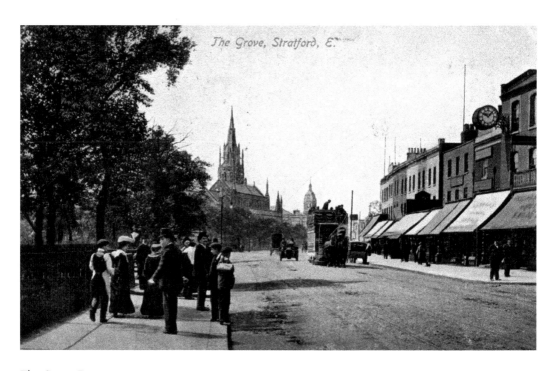

The Grove, Stratford, E.

The Grove E15

The large open space in the modern photograph is in front of a large Morrison's supermarket where the old pyramid offices once stood. There is also a large new library next to the supermarket, which has a memorial to Gerard Manley Hopkins outside who once lived in the Grove.

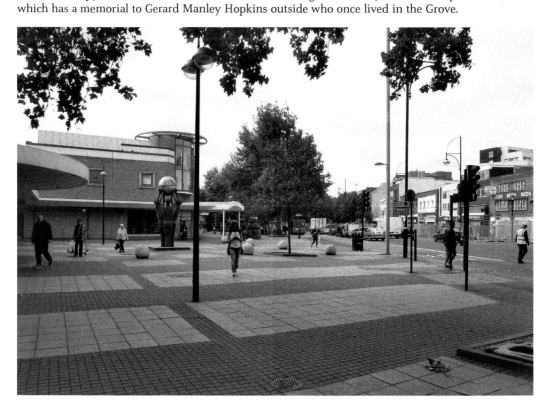

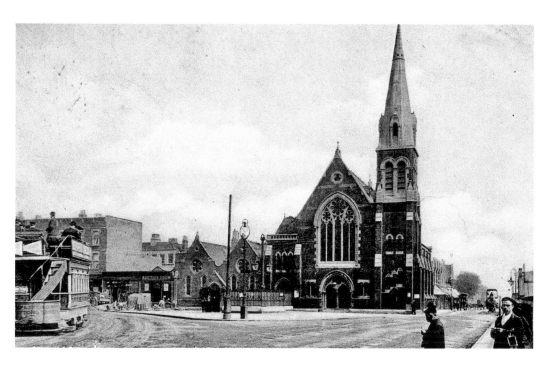

Maryland Point E15

The old photograph shows the large Trinity Presbyterian church, built in 1870. The church moved to new premises in Manor Park in the 1940s and the old church became a factory. It burnt down in 1953 but the hall remained in use as a factory until the early twenty-first century, when the area was cleared and the tower block in the new photograph was built.

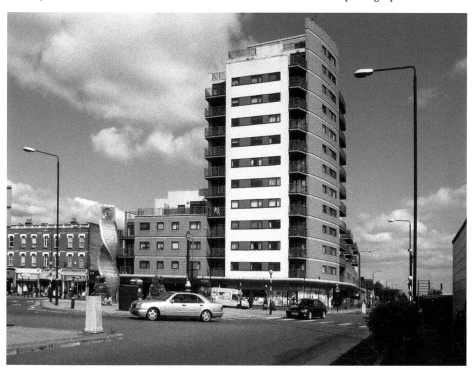

Shipman Road School E16

The school in the old photograph is a bit of a mystery as it no longer seems to exist and I have found little information about when it disappeared. The school that stands in Shipman Road today is St Joachim's Roman Catholic school, shown in the modern photograph. The present building dates from 1968 although the original building, still standing, dates from 1896 but is not the building in the old photograph.

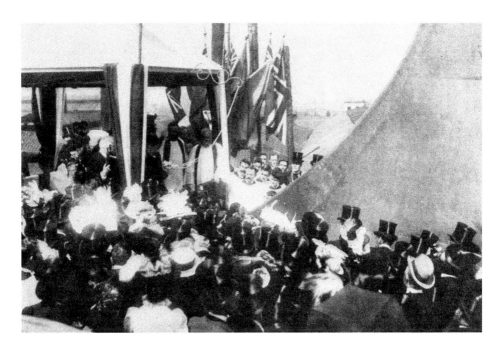

Thames Ironworks E16

The Ironworks stood on Bow Creek at Canning Town. They were best known for producing the new ironclad warships at the turn of the twentieth century. One of these, the *Albion*, was to lead to a terrible disaster. At the launch of the ship in 1898 a wave washed up onto a walkway crowded with spectators watching the Duke and Duchess of York. The royals knew nothing of the disaster until later. Thirty-eight people died in the river including men, women and children. The modern photograph shows the graves of some of the victims in West Ham cemetery. The names of all those who died are written on the stone slabs.

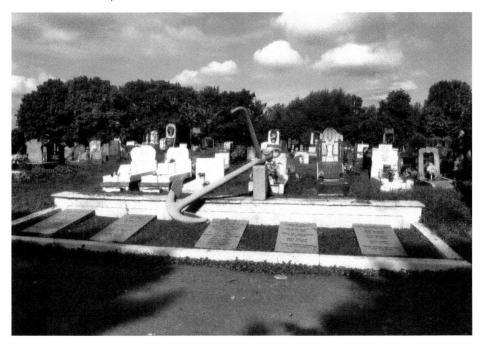

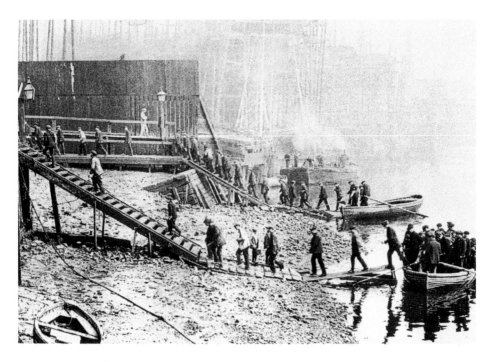

Thames Ironworks E16

The old image shows the arrival of men for work at the Thames Ironworks. As can be seen, many men arrived by boat. In one instance a number of men died when their boat hit the *Princess Alice* steamer, later to be involved in a disastrous accident on the Thames. The modern image is a view of the site of Thames Ironworks on Bow Creek close to what is now Canning Town station.

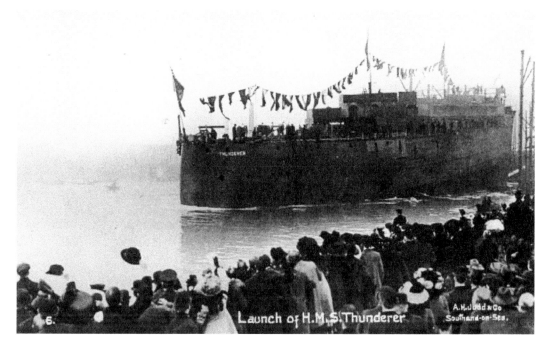

Thames Ironworks E16

The old image shows the launch of the HMS *Thunderer* in 1911. It was one of the best-known ironclad ships built at the site. The modern photograph shows the memorial to the Ironworks at Canning Town station. The metal plate comes from HMS *Warrior,* built in 1860 the first all metal-hulled warship.

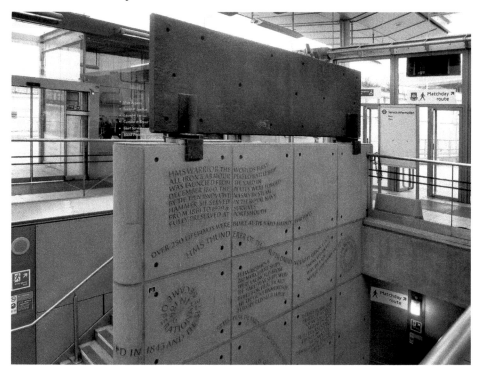

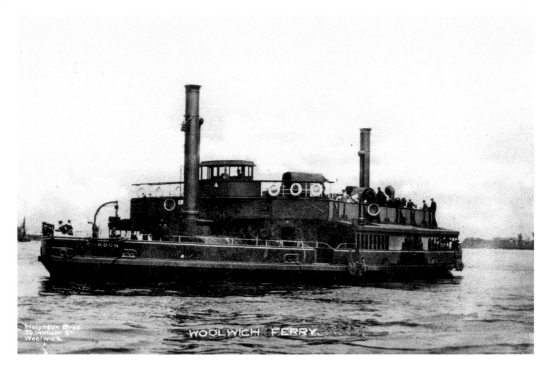

Woolwich Ferry E16

In the past a number of ferries operated on the Thames, and there has been one at Woolwich since medieval times. The Woolwich Ferry is one of the very few remaining. It carries foot passengers and vehicles across the river. The old photograph shows the ferry around the turn of the twentieth century, and the modern image shows one of the two ferries working today.

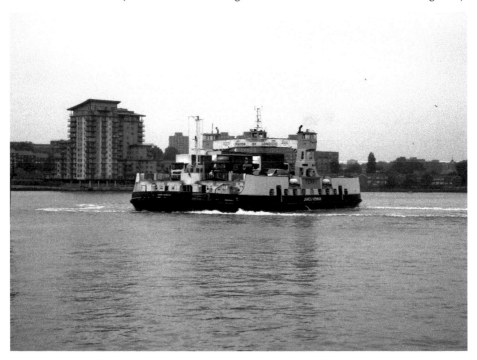

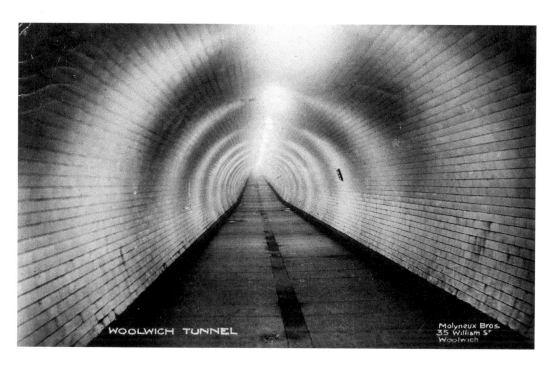

Woolwich Tunnel E16

The tunnel opened in 1912 and runs from North Greenwich to Greenwich. The entrance buildings are Grade II listed buildings. Upgrading work began in April 2010 but then the tunnel was closed completely in September 2010 due to weakness in the tunnel. It is not known when it will reopen.

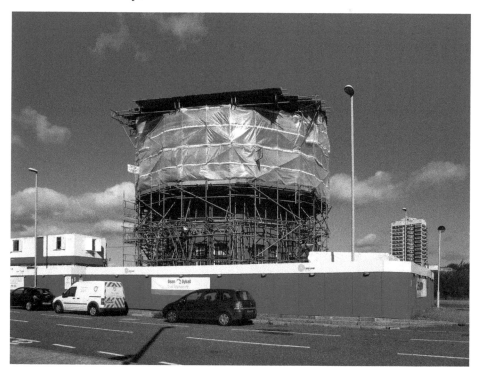

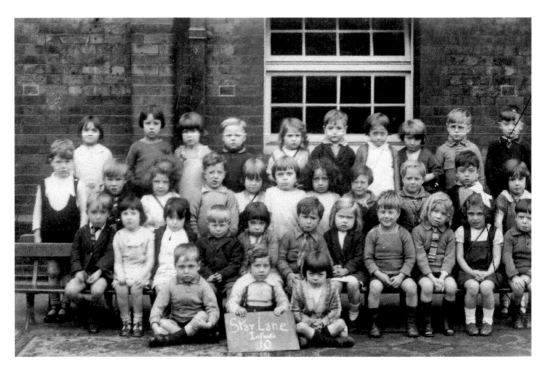

Star Lane School E16

Star Lane school in Canning Town is an old Victorian three-storey building. It has been extended with more modern accommodation and, as can be seen from the modern photograph, trees now line the playground. One of the school's more famous pupils was David Essex.

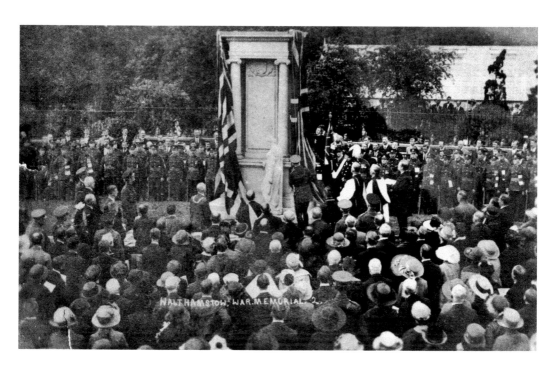

War Memorial E17

War memorials began to appear in large numbers after the First World War, and had been quite rare prior to this. The Walthamstow memorial is quite an unusual design with a Roman lady grieving for the loss of a loved one. The modern photograph shows the town hall, which has stood behind the memorial since it was built between 1937 and 1942.

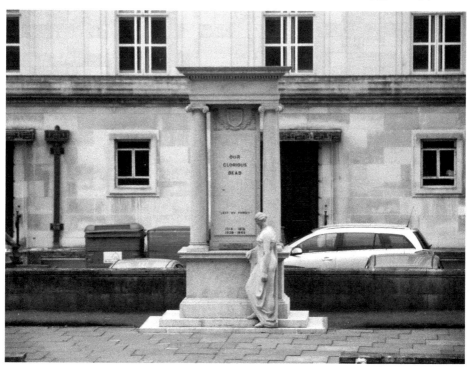

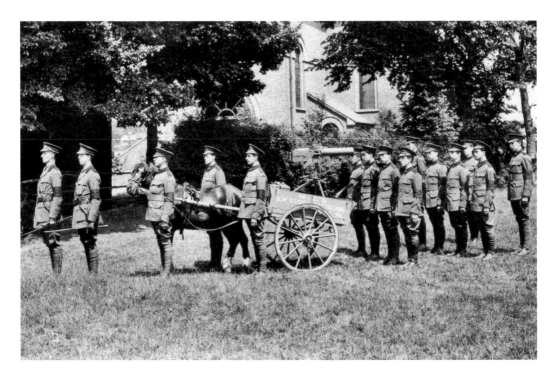

Army Volunteers E17

There were a number of volunteer army units in the years leading up to the First World War. The old image shows the machine gun section of the 11th battalion Essex Volunteer Regiment. The modern photograph shows the Territorial Army and army cadet base in E17 which is now the army volunteer force.

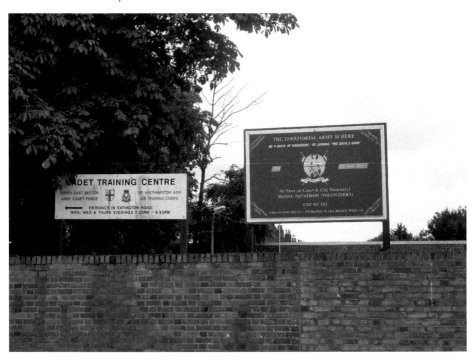

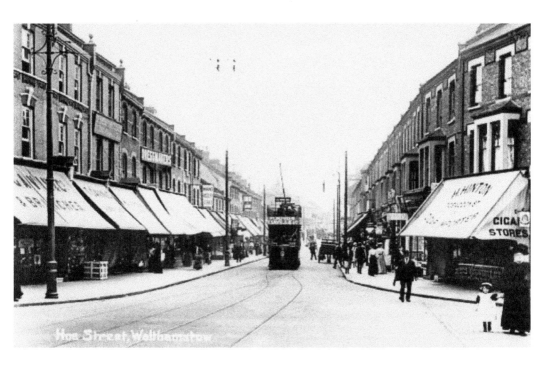

Hoe Street E17

Hoe Street Walthamstow was part of an ancient route from London to Waltham Abbey. It was no more than a small village in the nineteenth century until the railway arrived. Since then the area has grown to include a large number of houses and, as both photographs show, a large number of shops.

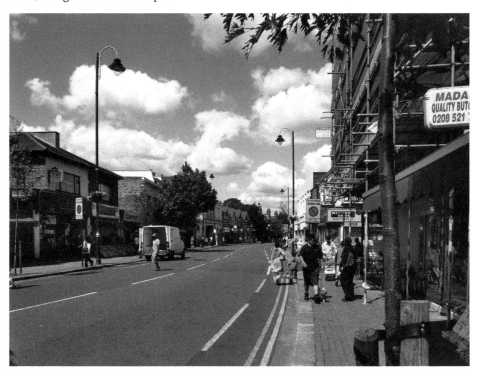

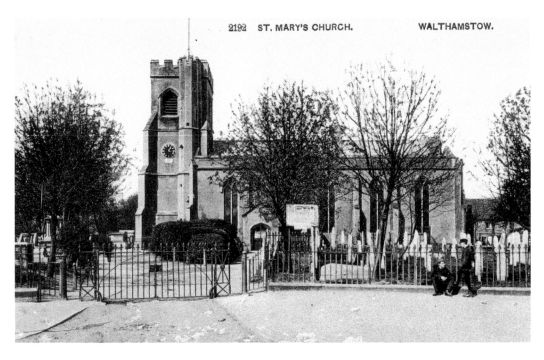

St Mary's Church E17

St Mary's church originally dates from the twelfth century although the church has been added to and extended since. There is a monument in the church dating back to 1436. The church stands in a conservation area with a number of fine old buildings, very different to the busy Hoe Street a short walk away.

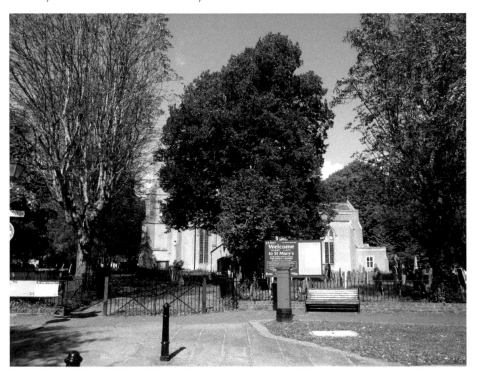

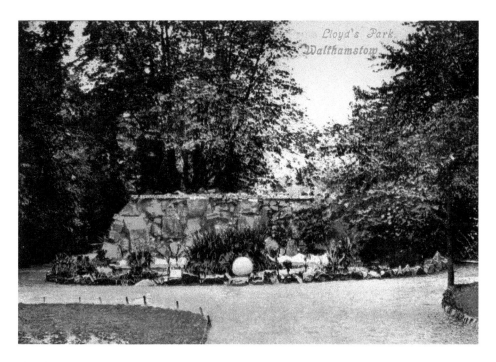

Lloyd's Park E17

The most famous thing about Lloyd Park is that it was once the grounds of the house owned by William Morris who lived in Walthamstow. Like many other Victorian parks in East London it has not aged well. It is now being revamped with National Lottery funding and is, unfortunately, closed at the present time.

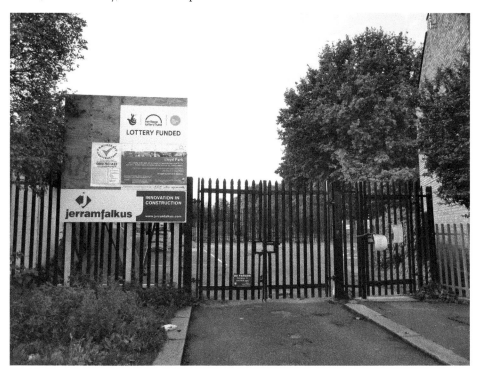

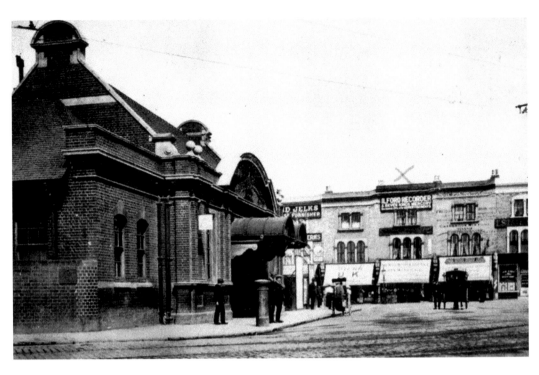

Seven Kings Station, Ilford

Seven Kings station opened in 1899 and was part of the Great Eastern Railway. The area was once well populated by Irish immigrants and there is a large Roman Catholic church and a secondary school close to the stations.

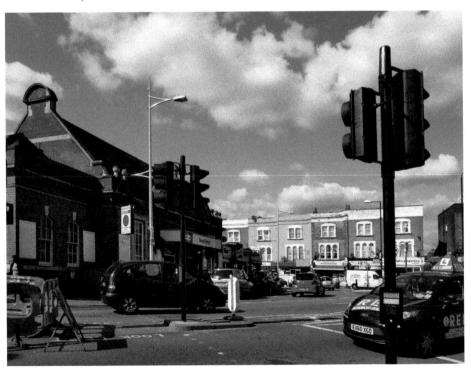

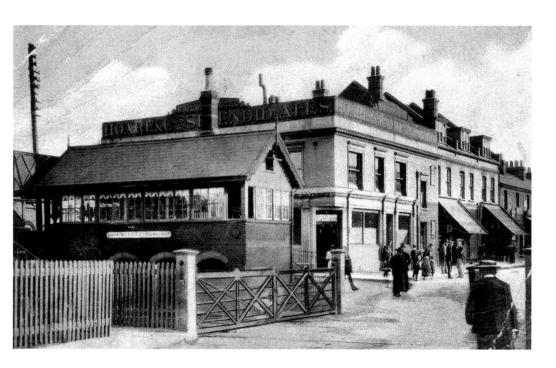

Barking Station

The old photograph shows that the station at Barking once had a level crossing for the trains to cross the main road. This has been altered for some time with the rails now running under the road and the station much extended.

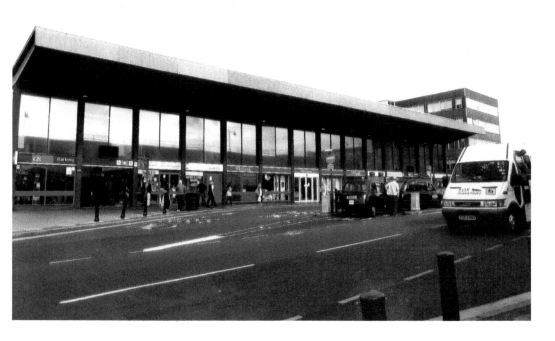

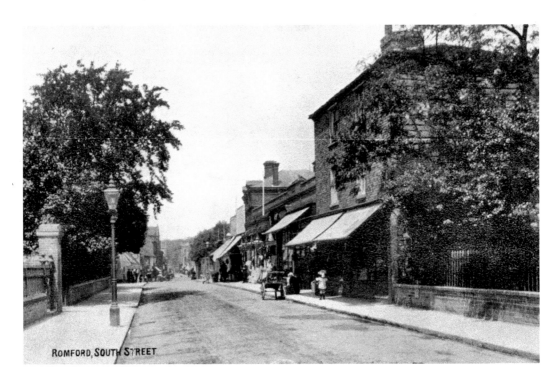

Romford South Street

In the old photograph there are a number of large houses as well as shops in South Street Romford. This has changed and shops now line both sides of the street from the junction with High Street and Market Place to well past the railway station. The large houses have all gone.

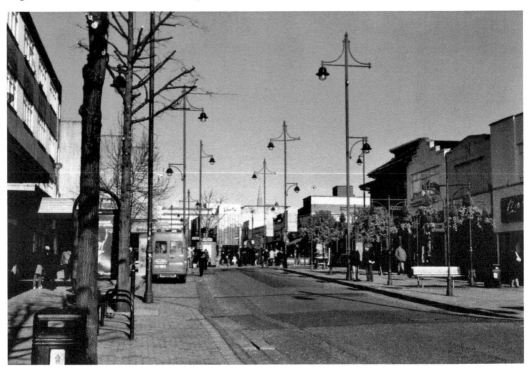